DC
GO-GO

DC GO-GO

TEN YEARS BACKSTAGE

CHIP PY

**FOREWORD BY
GREG BOYER**

THE
History
PRESS

Published by The History Press
Charleston, SC
www.historypress.com

Front cover, top left: The frontline singers from the all-female go-go band Bela Dona. *Left to right*: Bléz Coe, Wendy-Rai Rothmiller, Karis Hill and Claudia Rogers; *top right*: Fans dance stage front at a Rare Essence Show; *center*: Chuck Brown holds a mic to the crowd as they respond to his calls; *bottom*: Go-go icon D. Floyd entertains the large crowd that gathered to celebrate DC's Emancipation Day and Freedom Plaza on Pennsylvania Avenue.

First published 2022

Manufactured in the United States

ISBN 9781467150538

Library of Congress Control Number: 2021950583

Notice: The information in this book is true and complete to the best of our knowledge. It is offered without guarantee on the part of the author or The History Press. The author and The History Press disclaim all liability in connection with the use of this book.

All photos in the book are by Chip Py.
Courtesy of the District of Columbia Public Library's Go-Go Archive.
The People's Archive, www.dclibrary.org/thepeoplesarchive.

This book is dedicated to Ray Py

CONTENTS

CONTENTS

Contents

FOREWORD

I grew up just a little ways down the road from DC in Bryans Road, Maryland. I took to music at an early age. In junior high, I became a classically trained tuba player and could play just about any instrument by the time I was in high school. While in high school, I set out playing gigs in the local DC music scene. By that time, I had settled on the trombone for my axe.

In 1978, when I was nineteen years, old I joined George Clinton's Parliament Funkadelic and became a full-time funk musician, joining section mates Bennie Cowan and Greg Thomas. I toured the entire world with Parliament Funkadelic for eighteen years. I have spent eight years as a member of Prince's NPG band and am a member of Maceo Parker's band.

The first go-go band I heard live was Trouble Funk. It was just called "Trouble" back in those days. I might have already been a part of Parliament Funkadelic by then, so I could easily have been considered a funk snob. I wasn't a huge fan, but that didn't stop me from dancing to the pounding pulse that was their thing. Not long after, I gained respect for that brand of funk and quickly aimed to grasp the nuances.

I moved back to DC from Los Angeles in 1988, partly due to the urging of my P-Funk horns section mates Bennie and Greg, who also live in the DMV (District, Maryland and Virginia, for those who don't know). I started out with the go-go band Slug-Go and then moved on to Little Benny & the Masters. Chuck heard us P-Funk horns with Lil Benny and said how

much he liked the horns. Then he said, "I want y'all to play with my band, and I'm the only one in town qualified to pay you." We took him up on his offer in 1989, while simultaneously touring with the aforementioned funk bands. I'm in Chuck's band to this day.

I've played for numerous crowds damn near everywhere you can imagine. They dance, sweat, sing along and all the things that make a live audience great. But there's something in the way that a DMV audience throws right back at you what you throw on them. It's always the feeling that not all of the band members are on the stage with you; they are also in front of you. They're participants of the music being played, not just listeners.

And go-go does not go unnoticed. From George Clinton to Prince to Maceo Parker, they know the unstoppable pulse when they hear it. And I don't mind at all when they wish to engage in the topic of it. Some admire it; some want a piece of it to call their own. But Marcus Miller said it best to me when he spewed, "Man, y'all grow funk out the ground down there in DC!"

There's this thing I go through when I return home from outside the country—even outside the city. When I'm driving around with my radio on, I know I am back home when I hear that beat on the radio. It's not just the groove living in me; it's me living in the groove as well. "Dat Pocket" will always define how I think and feel musically.

In August 2015, I was quoted in the *Washington Post* as saying, "Go-go is DC's DNA and if you know anything about biology, that doesn't change." Those words hold more true today than they did when I said them because gentrification is a driving force (or at least a big contributor) in the effort to extract the aforementioned DNA from the city. An example of what "the structure" uses as a smear tactic: "That music is for undesirables and troublemakers"; read between those lines. However, they weren't counting on the pushback being so strong in the embodiment of the "Don't Mute DC" campaign. Many fans, musicians and citizens are quick to point out that go-go *is* DC. If you don't like it, it's as good as saying you don't like DC. That might also be considered a call to invest in more soundproof windows if "that music" is a problem for yous!

One thing you can trust *any* government on is this: "If it makes money, it's a good thing." An increase in productivity, a drop in crime, a fostering of the city's reputation are all going to factor into any governmental policy being real musical investment or political lip service. Skeptical as I might be, I'm hoping for the former.

Go-go is the DNA of DC. If you know anything about biology, DNA does not change. Scientists have been playing around with scientific blueprint since who knows when. But one doesn't need a biology degree to know certain things ain't to be messed with. They can try to alter deoxyribonucleic acid all they want, but genetic makeup is etched in cellular stone. Washington, DC, is that stone.

—Greg Boyer

PREFACE

I t was November 2011, and the "Godfather of Go-Go," Chuck Brown, and his band had chartered a tour bus to the Hampton Coliseum in Hampton, Virginia, to open a show for George Clinton and Parliament Funkadelic. I had been photographing Chuck, his band and the many other go-go bands that played nightly around Washington, DC, and its suburbs for a little over a year as a project I had self-assigned. I looked on the three-hour bus ride to Hampton as a chance to sit up in the front of the bus and chat with Chuck. In doing the work that I do, I don't like to get "in the face "of the subject, instead allowing the subject to forget about the photographer and allowing me to capture them as themselves in their own environment. I often refer to this as keeping a figurative "eleven feet" of distance from the subject in order to capture the subject in spontaneous fashion; that's how I like to capture a subject being themselves. Because of this, Chuck and I had spoken briefly only a few times in my role as his photographer. While most of the band watched a movie farther back in the bus or caught some sleep in one of the many bunks, Chuck and I chatted most of the way.

I asked him about the first time he and George Clinton had performed together. He stayed quiet for a few minutes and then said loudly, "1968! In 1968, George and I were booked into that Sheraton on Route 450. Man, they took one look at all of us when we arrived and said, 'Y'all aren't playing in the ballroom here.' So we set up and funked up that parking lot! Man, what a night!"

Chuck Brown kisses his wife of many years, Jocelyn, prior to boarding the tour bus to Hampton, Virginia.

It was during this ride that he asked me to call him "Pops," a nickname reserved for band members and others close to the band.

Upon arriving at Hampton Coliseum, we were shown to the dressing room by a representative from the venue. As everyone settled in, the venue representative announced she had a photo pass for a photographer. "That's me," I said. She held the pass up and sternly explained the rules to me: "Photographers must shoot from the designated pit area. Photographers can only shoot during the first two songs." Her tone became extremely firm and authoritarian when she got to the final rule: "After the second song, photographers must leave the pit on their own. If security has to step in and ask them to leave, their camera's cards will be confiscated, they will be thrown out of the venue immediately and will never ever again be allowed to shoot bands at Hampton Coliseum." I told her I understood her rules and asked her if she could show me the pit area prior to the show so I could consider angles, lighting and such things. I told her I had never shot the band from a pit because I am usually on stage with the band while they perform. She got all up in her chest and said firmly, "At Hampton Coliseum, no one but band members are allowed on stage."

Chuck was sitting on a folding chair just to my left taking this in. "Ahem," Chuck cleared his throat. That voice was famously raspy from singing over the percussion from his band nightly in clubs and performance venues not only in Washington, DC, but nationwide and worldwide. He said, "Excuse me, miss, in my band I have two drummers, three horn players, two beautiful women, several keyboard players and one photographer." She was taken back a bit by this for a minute, and then she handed me my pass and said, "Do whatever you want." Chuck leaned back in his chair and gave me an OK sign. Having my camera in hand, I was able to capture that moment with my Nikon.

I was in the band.

A bit later, Chuck asked me to walk with him to the stage later on when the time came. As the band left the dressing room for the stage, Chuck and I walked through the backstage maze. On that walk, he was very complimentary of the images I had captured during the previous year. Chuck stopped on the last step to the stage and said, "Hey, Kodak [he often

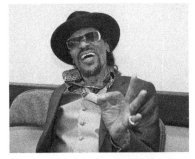

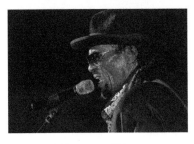

Top: Chuck Brown and his manager Tom Goldfogle backstage at Hampton Coliseum.

Middle: Chuck Brown gives me the "OK" sign after getting full-stage access for me at Hampton Coliseum.

Bottom: Chuck Brown performing at Hampton Coliseum.

forgot my name]. Do you know why you're here with me tonight and all the other nights?" "No. No, Pops, I don't." "Well," he said, raising his voice over his drummer Kwickfoot's snaring of the cymbals and the crowd calling out "Wind me up, Chuck." "You are here because it's important to my family, it's important to me and it's important to my legacy." My knees wilted, my heart skipped a beat, I lost my breath and Pops walked onto the stage. Moments later, I was able to pull myself together, step onto the stage and begin working—now with an extreme sense of purpose.

This book, my work with the DC Public Library's Go-Go Archive, where all of my go-go images are now archived and available to the public; the permanent display of my work at Chuck Brown Park; and the photo lectures I have done at libraries, coffee shops and community groups are how I carry that responsibility bestowed upon me by Chuck Brown, the Godfather of Go-Go. This book is not to be considered a complete history of go-go but simply a representation of my photographic work, as well as the things that I learned about go-go in the ten years I spent photographing not only Chuck Brown but the music, its culture, bands, artists and the fans who were active in go-go during this time.

SHOUT-OUTS

M any thanks to all those who played a role in making this book and these pictures happen, including:

Promoter extraordinaire Martin "Made in the City" Cooper. The first time I ventured into an authentic go-go, I was greeted by Martin, who, after some explaining, understood immediately the importance of the work I had begun to do. Martin, his brother Gennard and the Made in the City staff—Sheila "Peaches" Perkins, Miss Lorreta "Clip Board" Sims, Shonda Bonner and "Memories Worth Keeping" Fred—were more than gracious in accommodating me, treating me as part of the Made in the City family, not just that night but for the entire time I spent in go-go. Had Martin Cooper turned me away that night, I am not sure I would have pursued this project.

Chuck's manager Tom Goldfogle, who brought me on as one of Chuck Brown's photographers and welcomed me into the Chuck Brown Band family—a family that not only included Chuck and his band members but fans also who were tight with the band like Penny "Chinchilla" Braxton, Kevin Jones, Karla Braxton (RIP), Chuck Brown Crew chief Christopher Lee and stagehand "Packey."

Go-go's finest marketer, Maple's Finest Monique Michelle, who I met very early on in this project. Monique not only helped me navigate DC's go-go scene with tips and backstory but also became a good friend along the way.

Ron Moten and Natalie Hopkinson, whose vigilant activism turned the way the DC government viewed go-go and go-go culture 180 degrees from a problem to something to be cherished, supported and documented. It will be great to see their go-go museum flourish in the years to come.

The unofficial mayor of DC go-go, Troy "Too Smooth" Wills. If "Too Smooth" was in the house, you knew where the party was. I am glad to call Troy my friend.

The Special Collections people at DC Public Library—Kerrie Williams, Derek Gray, Laura Farley, Demetrius Curington, Phillip Espe and Michele Casto—for preserving these photos that capture the work of go-go artists, go-go fans and go-go culture forever as one of the DC Library's Special Collections and part of the Go-Go Archive—the People's Archive.

Artists, managers and tech crews of all the go-go bands that let me share the stage with them so I could get those tight shots with a super wide–angle lens. This allowed me to capture the relationship between band and fans, which is critical when capturing go-go.

Special shout-out to Donnell "D" Floyd, Cherie "Sweet Cherie" Mitchell-Agurs and Natasha "MzLaydee" Kelly, who throughout this whole project made themselves available to me for a quick call to answer a question, provide a band member's name and so on. A lot of what I learned about go-go I learned from these three friends.

My family. My newspaper reporter father, Ray Py, let me and my camera tag along with him to events that he covered and taught me how to look for a story that needs to be told. He also passed on to me his love of exploring to simply go "see what I could see," to document, to catch moments with my lens and most importantly to be passionately involved in my work, which I often do without an assignment from anyone. Had he not ingrained this in me, I would never have pointed my lens toward go-go, a music and culture that was completely foreign to me. My sisters, Beth Py-Lieberman and Stacey Flynn, are two great storytellers, documentarians and seekers of the facts, Beth in her role at the *Smithsonian Magazine* and Stacey in her role as a librarian. My brother-in-law Jim Lieberman's vast knowledge of government procurement played a huge role in smoothly transferring my work to the DC Public Library and the people of Washington, DC, where it is now archived for the future and beyond. I have tried to pass down my father's love of exploring to my nieces Claire and Patsy Lieberman and nephew Matt Flynn and now go to them for advice and such, as they are grown and wise. I am proud to say that all three of them know how to catch a groove and catch a fish. They ground me well.

My neighbor Ernie Long, who has shared his go-go stories with me from back in the day, providing a tremendous amount of insight into not only the music but also the culture of go-go.

My Wednesday night Covid Zoom Crew, all friends who I met at the go-go: Ron Blackwell, Tia Terry, Andre "Facemob" Benefield, Tanaya Thomas, Angela "MsVicious" Davis, Dashia Floyd, Kael Kelly Carter and Desma Nicholson, whose encouragement and support while I wrote this book was not only very helpful, but whose friendship helped me get through the Covid pandemic.

My acquisitions editor at The History Press, Kate Jenkins, who guided me through this process with perfection.

CHUCK BROWN AND THE ORIGINS OF GO-GO

Why is it called go-go? When someone from outside DC thinks of go-go, they think of the go-go craze from the 1960s and early '70s—scantily clad young women dancing in cages and wearing the famous go-go boots—but that has nothing to do with the DC go-go that is now the Official Music of Washington, DC (or just DC, as Washington, DC, is known to DC residents).

DC go-go is best described by reaching back to its origins and the story of Chuck Brown, DC's Godfather of Go-Go. While serving an eight-year sentence for murder at Lorton Penitentiary, DC's reformatory prison located nearby in Northern Virginia, Chuck Brown swapped cigarettes for a guitar made by a fellow inmate in the reformatory prison's industrial arts shop. Chuck began to learn jazz classics on this guitar, and as things progressed, he began to look at music as his way to never go back to jail again. Chuck began to consider his future as that of a working musician.

Upon leaving the prison system in the mid-1960s, Chuck began playing guitar as a sideman in bands such as Jerry Butler and the Earls of Rhythm, eventually landing himself a role in the band Los Latinos, where he developed a passionate appreciation for Latin rhythms played on the congas.

Meanwhile, kids from the Southeast DC neighborhoods had started fashioning percussive instruments from items they found along the street and things thrown in the trash. They would hitchhike over the bridges with their makeshift drums to downtown DC and play for change or often bills from the busy office workers, lobbyists and government bureaucrats who

populated the many office buildings. The neighborhood "junk bands," as they became known, played neighborhood parties and cookouts not only in Southeast and Northeast DC, the two quadrants of the city where the African Americans were the majority of the population. DC is a city of neighborhoods, and each neighborhood had its own junk band or two that often played at cookouts and other parties. Competition held between neighborhood junk bands became fun events. Unbeknownst to many at the time, they had developed a very distinctive beat.

As Chuck Brown's musical career moved forward, he formed his own band, playing soul and top-forty covers and eventually a lot of original music in the clubs around the city. As a bandleader, Chuck began to notice that people would get up and dance and enjoy themselves when the band played a song they liked, but as soon as that song was over, back to the tables they would go. Meanwhile, competition was coming from the popular discotheques that were popping up around town. They featured popular DJs

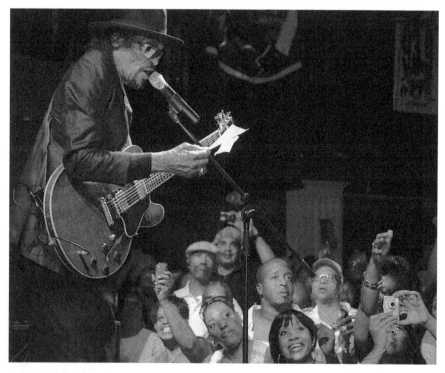

Notes are passed to Chuck Brown letting him know who is in the house celebrating a birthday or something else. Chuck will include the folks in a show-opening "roll call" or later make a callout during the show.

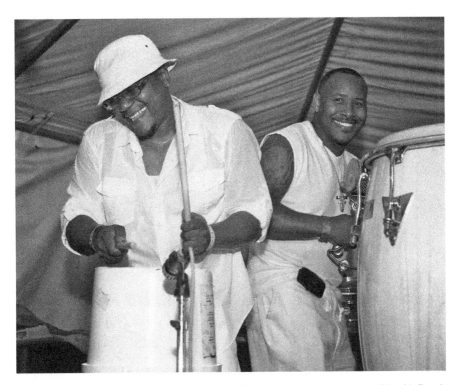

Chuck Brown's conga player and percussionist Mighty Moe plays a bucket in Chuck's Band.

who would blend one song into another, creating a party that never stopped. As the popularity of the discotheques grew, musicians began losing gigs. Work began to dry up.

In response to this, Chuck began blending the percussive elements and beat the kids from the junk bands were playing into their band, along with the Latin congas that Chuck had become keenly fond of during his time with Los Latinos. Buckets, Cowbells, Congas, as well as a drum kit now formed the backline of Chuck's band.

It was this percussive backline, which formed the beat played between and often during songs that began to define Chuck's music. A gospel element was also added. The call and response from the African American churches began to appear as communication between the bandleader and the audience; this important role in go-go would soon be known as the lead talker. Chuck also made it his responsibility as a bandleader to work the crowd just prior to each show and find out if any special occasions such as birthdays or anniversaries brought them to the club each night or what

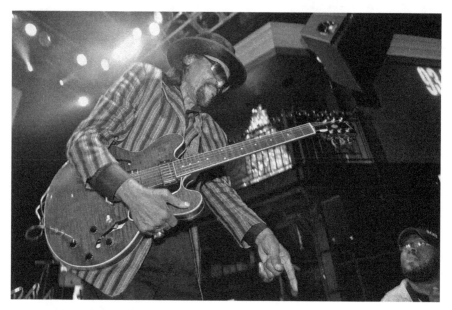

Go-go bands prefer to be really close to their audience. Chuck Brown tells security at the 9:30 Club to remove the barriers that move the audience back a few feet from the stage.

neighborhoods the partygoers were from. These became his shout-outs later in the show and kept the audience involved. Soon, notes began to be passed from the audience to the lead talker for birthday shout-outs. Chuck became keenly aware of how the audience reacted to the music being played and their enjoyment level and began to make immediate adjustments on the fly to keep the party going, never pausing between songs.

He called this music go-go because the music never stopped.

GO-GO 101

PERCUSSION

One cannot speak about go-go without speaking of the distinctive percussive nature of the music. As a subgenre of funk music and in James Brown's style, each instrument is "considered a drum" and is involved in the beat. The guitar can be played as "scratching"; the keyboards not only provide melody but can also be played as part of the beat; and vocalists always have a tambourine nearby.

However, the drive of the beat comes from the backline of percussive instruments. Centered on a standard drum kit, the backline consists not only of the drum kit but also conga drums, roto toms, cowbell, blocks and often a bucket. The distinctive beat of go-go is created as a "conversation" between these backline players, with a cranking 4/4 beat as the centerpiece. When a go-go band is hitting on all cylinders with the heavy percussion leading the way, it is known as "cranking."

The characteristic centerpiece of go-go's percussive sound is the "pocket," a 4/4 beat and a critical part of a go-go performance that literally moves everyone in the venue, including fans, bartenders, security and waitstaff, into the same groove. This pocket groove is played between songs under the direction of the lead talker. The pocket and socket keep the beat going and going and going.

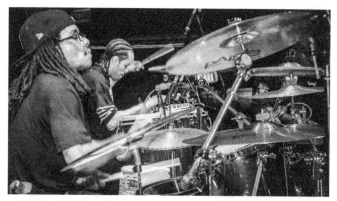

Top: No one will argue that the best percussive conversation takes place between Bo Jack and Go-Go Mickey, who played together for over thirty years with Rare Essence before joining Familiar Faces in 2011.

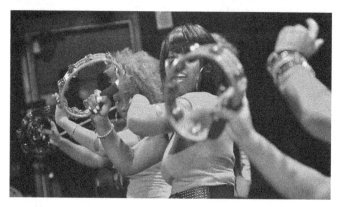

Middle: Black Alley's Animal and Bo Beady seem to share the same brain when they crank together. Notice the bucket on stage.

Bottom: Bela Dona's frontline, Bléz, Wendy Rai and Karis Hill, keeping it percussive.

ROLE OF THE LEAD TALKER:
"WHO ARE YOU? WHERE IS YOUR CREW?"

A first-time listener to go-go often wonders, "Why is that guy talking over the music?" That person is known as the lead talker, and the role they play is key in making go-go truly go-go. The role of the lead talker is twofold. The lead talker "reads" the audience and keeps them engaged with the band, on their feet partying. The lead talker also directs the band as they transition from song to song with deep pocket in between tailoring each show to the audience's preferences.

The lead talker uses several tools to keep the audience involved. Prior to each show, the lead talker will often mingle with the crowd, find out who came to the go-go that night and why they came out, who is celebrating their birthday or anniversary and who is hanging with their crew. The lead talker will make notes and keep this in mind for shout-outs from the stage, such as, "Who are you? Where is your crew?" "So-and-so got a birthday." "Is there a party over here? Is there a party over there?" "I know so-and-so is in the house." Often a lead talker early in a show will perform a "roll call" to call out significant people in the house based on the information they have collected. To have your name or the name of your crew called out by the lead talker is an honor. To have your name or the name of your crew called out by the lead talker when the band is recording the show is Gucci!

The other responsibility of the lead talker is leading the band through the show. A lead talker must "read" each audience and tailor the show night after night based on what they see the audience reacting to. Working without a set list, the band must be able to quickly adjust to what the audience prefers, and the lead talker will use hand signals, head nods and taps on the shoulder to notify band members of a coming change. But the most powerful tool they have, which will suddenly catch everyone's groove in the club, is to put the band in the "go-go pocket." While much of the talking a lead talker does is to the audience, the words "Hold on" and "Wait a minute" announced by the lead talker move the entire band in a split second into the percussive go-go pocket. When the band is cranking out the familiar pocket beat, the groove becomes

While there is seldom a set list in go-go, there often is a shout-out list.

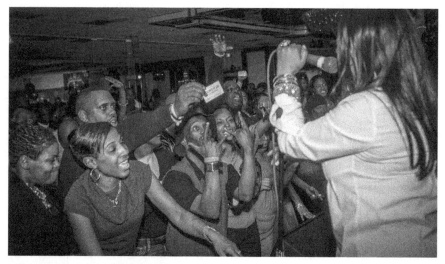

Above: A request for a shout-out is handed to lead talker Karis Hill on the back of a business card.

Left: Lead talker D. Floyd reads the audience, turns toward the band and signals them the next change. DC radio personality and comedian Huggy Lowdown mocks him in the background.

infectious; the pocket captures everyone in the house, including waitstaff, bartenders and sound crew, who move to the groove in unison. Lead talkers will hold the band in the pocket while they make callouts and call fans to the dance floor. They will often have the frontline performers tease the beginning of the next song while calling back the pocket beat again, with a familiar "Wait a minute" driving the crowd. This can be done several times before the lead talker signals the band to continue to the next song. If the audience is not responding, that song can be stopped with another "hold it" from the lead talker. It is not unusual for a go-go band to play a popular song completely through all the verses one night and only play a verse or two of the same song the following night, based on audience reaction. This becomes a "conversation" of sorts between the band and those in attendance. Occasionally, an audience will start singing a song they want to hear over the song that the band is playing; the lead talker will "read" this and quickly change the song to the one that audience wants to hear. This makes go-go truly the people's music.

CALL-AND-RESPONSE AUDIENCE INTERACTION

With the pocket beat bringing everyone in the house into the same groove and the lead talker interacting, making callouts, keeping the party going and tailoring the band's performance to the preference of the crowd, the interaction between band and audience is key. Fan interaction during a go-go performance is a large factor that makes the go-go music distinctive.

Call and response between band and audience is a regular part of any go-go show. The lead talker not only talks to the crowd, but the crowd also talks back to the band. At the beginning of every Chuck Brown show, Chuck toys with the audience with some call and response.

Chuck: "What is it you want me to do?" Audience: "Wind me up, Chuck!" Chuck: "I can't hear you!" Audience: "Wind me up, Chuck!!" Chuck: "A little bit louder!" Audience: "Wind me up, Chuck!!" When everyone is on their feet and chanting as loud as they can, only then does Chuck signal the backline to start playing the familiar beat. Band members step onto the stage one by one and begin playing their parts. When the horn section starts, the band is all playing together and fans are on their feet. The infectious pocket beat takes over. Toward the end of a Chuck Brown show, the audience will engage Chuck by screaming, "Chuck baby don't give a what!" Chuck replies, "That ain't true." Audience: "Chuck baby don't give a what." Chuck: "You know I do!" Audience: "Chuck baby don't give a what." Chuck: "I love all of you!"

Rare Essence's Jas Funk will say, "Tell me what you feel like doing, y'all." He holds the microphone to the audience, which says: "I feel like having a party." Jas Funk: "Tell me what you feel like doing, y'all." Audience: "I feel like moving my body!" Jas Funk: "Tell me what you feel like doing, y'all." Audience: "I feel like loving somebody."

L'il Benny: "I've been walkin' and also talkin'." Audience: "Go ahead, go ahead." L'il Benny: "We are groovin' and cuz y'all movin'." Audience: "Go ahead, go ahead." L'il Benny: "I've been thinking and also keeping." Audience: "Go ahead, go ahead." L'il Benny: "Are you tired yet?" Audience: "Hell no!" L'il Benny: "Are you ready to quit?" Audience: "Hell no!" L'il Benny: "Are you ready to split?" Audience: "Hell no!" L'il Benny: "Where's the party at? Is the party over here? Is the party over there? Is the party on the left? Is the party on the right?"

Bela Dona's Miss Karis will shout, "Eeee aay! Eeee aay!" and then turn the microphone to the audience, which replies, "Woooooo!"

Most go-go shows are not played in venues that are built for music, so bands will set up without a stage. Bands play eye to eye with the front-row

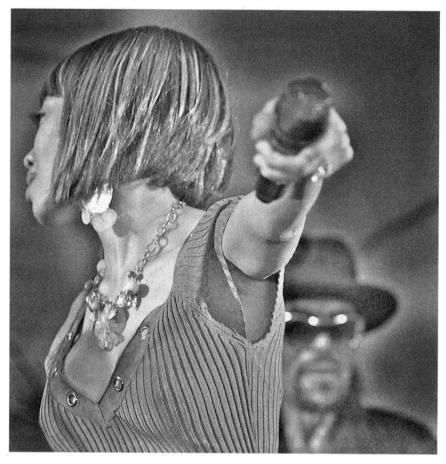

Ms. Kim holds the microphone to the audience for their response, where they sing the
chorus of her popular version of "Pieces of Me."

audience. Nothing but a few monitors separates them from the fans. "Ladies
to the front!" is a common shout from the lead talker.

Another shout from the lead talker—"Where the honeys at?"—will lead
to a response of "Over here," followed by "Where the real honeys at?"
and "Are the honeys over here? Are the honeys over there?" This call and
response often leads to the frontline band members reaching into the crowd
to a few select ladies, inviting them into the stage area where they stage
dance with the band. Ladies celebrating their birthdays would also have
a hand extended to them to join the band onstage for a dance. Returning
citizens who have been away for a long time who are now back in a very
unfamiliar society are often brought onstage for a dance.

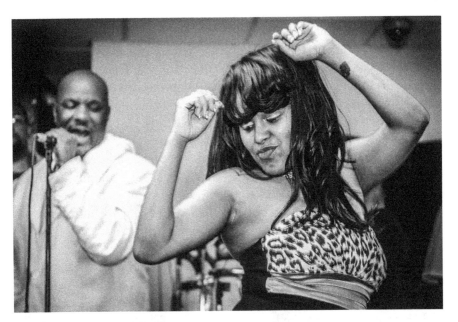

Lead talker D. Floyd calls the ladies to the stage to dance.

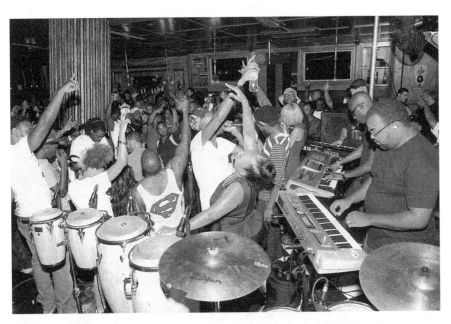

Most go-go music is not played in venues designed for live music, which often allows for the band and audience to come together as one, as seen in this Backyard Band performance.

Experience Unlimited's Sugar Bear closes most of his shows with his 1988 chart-busting song and dance, "Da Butt," by reaching out and inviting the ladies to dance on stage. At a show at the Howard Theatre, Sugar Bear invited this author/photographer to help with the choosing, inviting and pulling the ladies to the stage—a memory he will never forget.

Tradewinds Restaurant in Prince Georges County, Maryland, had a great run for many years as a popular go-go spot. Bands such as Rare Essence, Backyard Band and others had regular nights there and packed in large crowds. There was no stage at Tradewinds, so the band and fans were eye to eye. Rare Essence, on their years-long Friday night stand there, would open their third set, which occurred in the wee hours of the morning, with a "Where the honeys at?" shout with a musical melody and beat to it. Band members would reach a hand to many ladies, pulling them into the stage area, where they would not only dance but also grind and twerk with the band members. Cowbells, tambourines and other handheld percussive instruments were found lying about, and it was perfectly OK for the fans to pick them up and crank the beat with them Unlike other go-go shows, this would continue on for the entire final set; the band and fans would become one for the remainder of the show. This is something to see, something to be a part of.

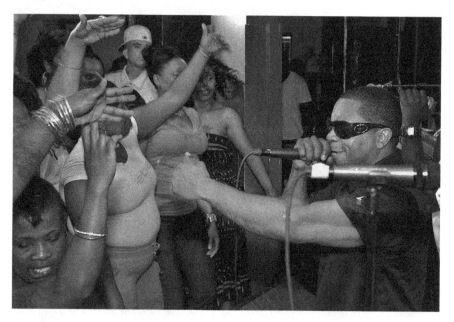

Rare Essences Shorty Corleone performs eye level with fans at Tradewinds.

Callouts from the lead talker, the infectious beat of the pocket shared by all, the audience being followed closely by the lead talker and then the music adapting to meet their taste, stage dancing and eventually feeling one with the band all make for an experience that makes everyone involved part of the music. Experiences like these don't take place when go-go is put onstage in regular music venues; it's not captured on studio record albums. Go-go is difficult to put into a three-minute radio-friendly song. It's simply an experience now in its fourth and fifth generation in DC and also why go-go fans are not only fans of the music, but go-go has become their defining culture.

THE CULTURE

G o-go music is no longer just a genre or type of music unique to DC; it has become the culture of Washington, DC's African American residents. The culture of go-go hides in plain sight to those who know little about the genre and culture. While the culture of go-go exists in the clubs where the music is performed, go-go culture is apparent throughout DC and its neighboring suburbs in many ways.

A go-go is a place to be seen, to represent not only yourself but your social affiliations, the neighborhood you grew up in, your family and your crew. Go-go promoters offer table packages including bottle service for sale for social groups, crews and such. Gathering in front of the stage for the lead talker to recognize you, your friends and your crew with a shout-out or "Is there a party over there?" call-and-response exchange tops the night, especially if the band is taping for a "PA CD" to be sold in the stores or played on DJ Big John's radio show, *Dat Bama Be Crankin*, or in one of DJ Dirty Rico's radio mixes. It is the mix and mingle, for those who are single (sometimes not) becomes the talk of the room during and after the go-go.

PORTRAITS

These nights at the go-go are also remembered through portraits. Well-lit portraits are taken with makeshift lighting. Backdrops with flashy images of top-shelf liquor bottles, fancy cars and personal jets are always set up in the corners at go-gos. Photographers are ready to snap that photo of you, your

friends and your crew, printing out as many copies as you want, which are carefully placed in a paper folding frame for a fee. Ladies know that it is always a good idea to have these portraits done upon arrival or early in the show rather than later because makeup, hair and outfits will have a different look once the "ladies move to the front" and the heated night of dancing begins.

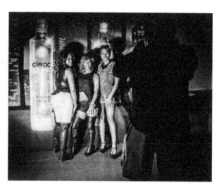

Ladies getting their portraits prior to arriving to a Backyard Band show.

The most well-known backdrop portrait photographer in go-go is Gregory "Mr. Gee" Sanders. Mr. Gee has been taking these backdrop photos since the beginning of go-go and continues today. He has also taught many of the backdrop portrait photographers on the scene today the intricacies of creating these keepsake portraits in a dimly lit room as well as the hustle involved in generating customers, which is a challenge in this day of phone cameras and the instant gratification of social media. One of Mr. Gee's most famous portrait scenarios often associated with the culture of go-go consists of a round-back wicker chair placed in front of the backdrop. Throughout DC, these portraits remain in photo albums and shoeboxes and are framed and hanging on walls as a keepsake of the nights at the go-go.

Nights at the go-go are also captured by roving photographers, often referred to as "the camera man," who are more than happy to snap a photo of you and your friends enjoying yourselves at the go-go. The photos are later posted to the promoter's social media pages in albums specific to the show with the promoter's logo stamped in the corner. Attendees tag themselves in these pictures and share them out, not only showcasing themselves but also in turn promoting the promoters, the parties and the regular go-go venues, often referred to as "spots." Back in the day, the cameraman would use a Polaroid and charge a fee to hand you the print, dressed in a matted bifold frame.

FASHION

As go-go grew toward the "grown and sexy" subgenre of go-go, many shows began having dress code requirements. Often, the dress codes are

based on the theme of the show, such as all-white parties that begin on Memorial Day and all-black parties in the winter months. "No skinny jeans" and "Proper attire" often appear on flyers promoting a show. However, depending on the evening's turnout, the doorman at the party might allow you in if you are not dressed accordingly—if you add twenty dollars or more to the cover charge.

Go-go has put a stamp on local fashion that can be seen throughout DC's African American community. While wearing national brands, DC go-go folks always find ways to alter their clothes, wear them and rock them that are unique to go-go. Ladies will occasionally hand-paint designer jeans with colorful bursts and graphics similar to the graffiti seen around DC. The jeans might have the name of the go-go band featured or a saying associated with go-go.

Local brands specific to go-go fashion such as alldaz, We R One, Shooters and Madness Connection became very successful locally. Specifically designed "drop socks" seen at go-gos caught on around DC.

Go-go-specific T-shirts featuring Mickey Mouse were at one time a huge sensation in go-go fashion. Local artist Deemont "Peekaso" Pinder, who can often be seen painting one of his distinct works of art onstage, is one of many artists who have hand-painted shoes particular to go-go. The leader of the Backyard Band, Anwan "Big G" Glover, has his own limited-edition sneaker with NBA star Patrick Ewing's Ewing Athletics.

DANCE

Popular dance styles emerge from many music genres, and DC's go-go is no exception. Dances like "Da Butt," associated with the band Experience Unlimited; Junkyard Band's "Hee Haw"; Da Mixx Band's "Power Dance"; North East Grover's "The Rumble"; Bounce Beats "Beat Your Feet" dance style and Rare Essence's "The Lock It Dance" and "Work the Walls" are popularly seen at the go-go.

Probably one of the best-known dances associated with the go-go genre is "Da Butt." It was featured in Spike Lee's 1988 film *School Daze*, along with the song by the same name. Written by Marcus Miller, the song was recorded by DC go-go band Experience Unlimited for the film. Spike Lee introduces the dance in the film, and it is then performed by Sugar Bear and Experience Unlimited. The musical number from the movie became a popular music video and gained worldwide attention. At Experience

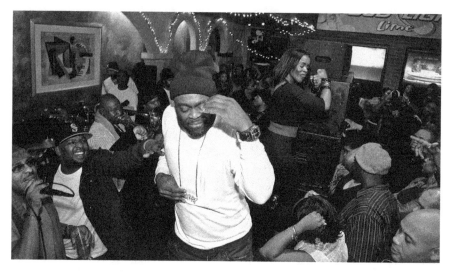

Fans take to the stage area to do the Power Dance at Da Mixx Band show at Club Elite.

Unlimited shows today, Sugar Bear and the band perform the song as a show closer, with band members pulling fans onto the stage to do Da Butt dance, thus closing out the show with a bang. Experience Unlimited also had a dance associated with it known as the "Cabbage Patch."

A notable dance was Da Mixx Band's Power Dance, performed as they played their song by a similar name. The dance consisted of audience members flexing their biceps while moving their wrists and heads from side to side. Fans and band members did the dance, and regular fans joined the band on stage to perform it as well.

The Beat Your Feet style of dance came out of the go-gos and moved beyond the clubs and venues, with young generations of go-go fans doing the dance in many places not associated with go-go. The Beat Your Feet dance style originated from Junk Yard Band's dance the "Hee Haw" but became a much more modern and fluid dance style known for very rapid foot movements. Beat Your Feet dancers develop their own dance moves and skills, known to dancers as "tricking it out" as a form of self-expression. This new generation of go-go fans from the African American neighborhoods of DC beat their feet in schools, in community centers, in Boys and Girls Clubs, on street corners, at parties and just about anywhere while listening to go-go music.

John "Crazy Legz" Pearson is not only known for his Beat Your Feet dance moves, but he has taken it upon himself to teach the Beat Your Feet style of dance to the youth of DC at schools and recreation centers and also

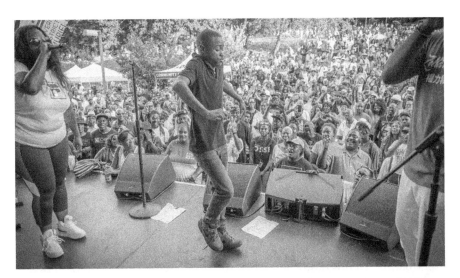

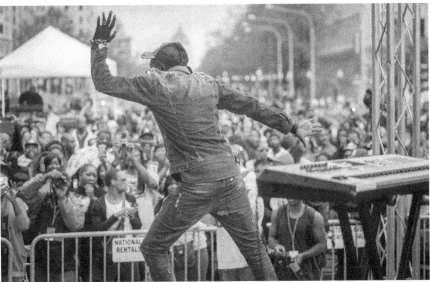

Top: A Beat Your Feet dancer is brought to the stage with the Chuck Brown Band.

Bottom: Lock It dance creator Bernard "Pee Wee Herman" Brooks shows off his moves to thousands on Pennsylvania Avenue to celebrate DC Emancipation Day.

everyone, young and old, beyond the DC city limits. He has even taught the DC-originated dance as far away as Poland. Five dancers got together as the Beat Ya Feet Kings, representing DC and the dance to a nationwide audience on MTV's competitive dance show *America's Best Dance Crew*. Beat

Your Feet dancers can be found regularly around the downtown areas of DC performing on street corners where tourists, lobbyists and businesspeople fill their tip buckets with cash just as the go-go bucket drummers do.

Rare Essence's Lock It dance is probably the most performed dance in go-go. The dance was originally created when go-go fan Bernard "Pee Wee Herman" Brooks began doing the dance at a go-go while Rare Essence performed their original song "Lock It." Made up of specific arm and shoulder movements in which the shoulders and elbows "lock" at certain points combined with side-to-side movement of the feet and body, this dance caught on as the audience and band began performing it in unison. The dance spread throughout go-gos, and many bands began to cover the Rare Essence song and dance. The Lock It dance has truly become a staple of most go-go shows. Chuck Brown added it to his shows, as did Bela Dona and other bands. To this day, when Bernard "Pee Wee Herman" Brooks attends a go-go show, he is often called from the audience onto the stage, where he performs his very tight, well-syncopated Lock It moves.

RELIGION

As go-go music has grown throughout DC's African American community, it has made its way back into the gospel of DC's African American churches.

Many churches in the DC area—like Pastor Darin Cloud's Soul Factory Church in Lanham, Maryland; the Reverend Willy Wilson's Union Temple Baptist Church in Anacostia; Apostle Steve Young's House of Praise; Reverend Keith Battle's Zion Church; and the First Baptist Church of Glenarden—have go-go bands as their church bands.

Go-go bands have formed around their faith, as is the case with Submission Band, Exodus Band, Ten Commandment Band, Mission Band, Peculiar People and many others. DJ DK has a popular show on Go-Go Radio, the Internet radio station that plays go-go gospel music exclusively.

While many churches have live go-go bands in their churches to preach the gospel, the church most closely tied to the go-go community is Reverend Tony Lee's Community of Hope African Methodist Episcopal Church, which began holding services on Sunday mornings in the now-defunct the Legend Night Club, a known go-go spot. Working under the theme of inclusivity, "Where Everyone Has a Chance," Reverend Tony Lee; his mother, Reverend Dr. Nancy Lee; and his brother Reverend Bill Lee have built a church community within the go-go community. They have been

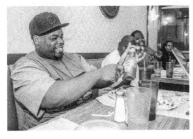

Top: Reverend Tony Lee in front of the deserted Legend Night Club, where he founded his Community of Hope AME Church.

Bottom: Kwickfoot lays down a beat on the condiment bottles at the Drummer's Breakfast while Buggy, Stomp and DonJuan Staggs look on.

known to have some of the finest go-go drummers—such as Chuck Brown's Kenny "Kwickfoot" Gross, Black Alley's Animal, Da Mixx Band's Larry "Stomp" Atwater and Familiar Faces' Jeffrey "Jamin Jeff" Warren—to perform at their Sunday services. Community of Hope's popular Monday evening youth nights have featured the go-go bands Backyard Band, Junkyard Band and TCB playing what Reverend Tony Lee refers to as "peace go-go." The Community of Hope soon grew out of the space at Legends nightclub and for many years operated out of a large lower level space in the bottom of the popular Iverson Mall. They now hold services in the Skate Palace across the street from the mall. The Skate Palace was once known as Crystal Skate, a popular skating rink that back in the day hosted many of the hottest, largest go-go shows.

At the time these photos were taken, DJ Dirty Rico and DJ Big John "Dat Bama Be Crankin" hosted what was known as the "Drummers' Breakfast" every Sunday morning from 4:00 a.m. until 8:00 a.m. at the Ranch House Restaurant in Oxon Hill, Maryland. The purpose of the Drummers' Breakfast was two-fold: first, it was where the drummers "spilled the T" about the latest in go-go gossip, which DJ Dirty Rico would videotape and post on his popular "The Noise Maker Nation" YouTube channel; second, it kept the drummers from going home, falling asleep and missing their church gigs. Go-go shows are known for rarely starting on time, but being on time for a church service is a must. For a go-go drummer, attending the Drummers' Breakfast allowed them to arrive at their church gigs fed, sober and relaxed. The Drummers' Breakfast was always a lot of fun and gave drummers a chance to bond with one another.

GRAFFITI

Go-go culture can be seen throughout the landscape of DC, as go-go graffiti and tagging brought the culture outside the clubs and to the buildings, streets and buses. Regular go-go graffiti artists include DC Monie, Gangster George, Godfather, Lisa of the World, Sir Nose 84, RE Randy, Tanya F, What's Up Woody and Cool "Disco" Dan. By becoming a tagger, one could increase their presence in go-go and draw callouts from the bands.

The best-known tagger from the DC go-go scene was Cool "Disco" Dan. Danny Hogg, a shy teen from the tough neighborhoods of DC, who had isolating social tendencies brought on from a lifelong battle with mental health issues, tagged the city of DC prolifically with his unique, simple Cool "Disco" Dan tag. This tag was everywhere in the city on building walls, storefronts, phone booths and taxicabs—simply everywhere! People of all sections of the city took notice. His tag extended throughout the city and out to the suburbs as he tagged Metro buses and DC's ever-expanding Metro subway system. He placed a large focus on the backside of walls facing the Metro's busiest line, the red line, along with tags in and around each station. Talk of Cool "Disco" Dan was spoken in every social sector of the city. The shy Danny Hogg remained anonymous while his fame grew. In 1991, *Washington Post* reporter Paul Hendrickson used his street connections and sought Danny out. Danny agreed to meet him at a downtown coffee shop under the condition that his real name not be used in the *Post* story. During the interview, Danny appeared to be unaware of his notoriety and began to realize that he could be arrested for vandalism, so following the interview, as *Washington Post* photographer Andre Chung went to photograph Danny in front of one of his large tags, Danny pulled a bandana from his pocket and placed it over his face, bandit style. The story and photo ran the following day under the headline "Mark of the Urban Phantom" on the front page of the *Post*'s Metro section. Danny had secured his image as a mysterious underground bandit of superhero proportion to all the residents of DC.

The life of Danny Hogg, as well as several other go-go taggers such as "Lisa of the World," "RE Randy," "Tanya F" and "Gangsta George," was the subject of the 2013 documentary *The Legend of Cool Disco Dan*, produced by Roger Gastman and Joseph Pattisal and narrated by DC punk pioneer Henry Rollins. The film followed Danny's life; the emergence of two underground music scenes of the '80s, go-go and punk rock; and the graffiti associated with the culture, paralleled with the events happening in DC from the crime to the crack and AIDs epidemics, Reaganomics,

gangs and the rise and fall of Marion Barry. All of these events from the '80s shaped Washington, DC, into what it is today. This was one of just a few times when Danny Hogg revealed himself as Cool "Disco" Dan. For the release of the movie, a large three-day event was planned that included "Pump Me Up," a curated art and memorabilia show at DC's prestigious Corcoran Gallery of Art; a red carpet premiere of the film at the American Film Institute's fully restored Art Deco AFI Silver Theatre and Cultural Center in Silver Spring, Maryland; and a daylong concert at DC's 9:30 Club featuring both go-go and punk bands from that era. This event was received extremely well by the DC media, the DC art world and DC's cultural community. All three events were the hottest ticket in town, and the film helped to shine a light on

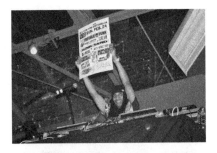

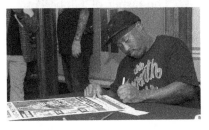

Top: Legendary DC rapper DJ Kool spins from the lofts of the 9:30 Club as part of the three-day event Pump Me Up.

Bottom: Cool Disco Dan signs posters at the showing of the movie *The Legend of Cool Disco Dan*.

go-go, punk rock and graffiti as cultures associated with Washington, DC. All of this attention to himself, his work and his legend was simply too much for shy Danny Hogg to handle, and he chose not to attend any of these events. He did appear at a later showing of the film at the AFI's Silver Theatre and Cultural Center, where he signed autographs and posed for pictures.

Sadly, Danny "Cool Disco Dan" Hogg passed away on July 26, 2017. A homegoing celebration for Danny was held at the 9:30 Club a month later, and the Howard University Gospel Choir and Rare Essence performed. Cool "Disco" Dan's work has been immortalized in DC. The side of a building with one of his tags on it and a tagged Metro switchbox found on the red line following his passing are on display as works of art in the John A. Wilson Building, DC's City Hall. The Fourteenth Street Graffiti Museum opened on October 3, 2020, in which Danny "Cool Disco Dan" Hogg is honored with a mural as the major centerpiece of the museum. Tags from go-go taggers "Lisa of the World" and "Re Randy" are also represented at the museum.

SEEN ON THE STREETS

Large poster placards with bright DayGlo colors, printed by the hundred-year-old Globe Poster Company in Baltimore, Maryland, were seen throughout the city, pasted to the windows of empty storefronts, tied to streetlight poles and slapped on every breaker box in the city, advertising upcoming go-go shows. These posters, which were once seen all over the country, became symbolic in their association with go-go and Washington, DC. The owner of Globe Poster, Bob Cicero, credits funk and go-go with keeping Globe in business as printing technology changed in the late '90s. Sadly, Globe Poster closed its doors in 2010. A group was formed known as Friends of Globe Poster to pay the rent on the warehouse until the thousands of Globe posters that were strewn about the warehouse in piles could be archived and preserved. Today, original Globe Posters are highly sought-after collector items and are often framed and displayed in people's homes and galleries. Social media has replaced the need for outdoor postings advertising go-go shows, and these posters have become representative of DC's go-go culture and history.

THE ARTS

Washington, DC, has a Go-Go Symphony, founded in 2012 by Oberlin College graduate and classically trained composer and conductor Liza Fiqueroa Kravinsky. Kravinksy had been composing, directing and performing with such artists as Prince on his Paisely Park Projects and worked as a touring musician for such bands as Motown recording artist Stacy Lattimore, as well as go-go bands Trouble Funk and Pleasure.

Working closely with go-go drummer William "JuJu" House, Kravinsky combined classic compositions with the go-go beat, adding MC Head Roc in the role as lead talker. Utilizing go-go artists Steph Jones, Mighty Moe Hagens, Cherie "Sweet Cherie" Mitchell-Agurs and Nate Johnson, the Go-Go Symphony has played to a wide range of audiences outside the regular go-go circuit, often bringing people to their feet dancing who had never heard the go-go beat or experienced go-go culture before. Not only has Kravinsky's Go-Go Symphony brought the go-go genre to many for the first time, but symphony musicians from all over began to take notice, and now it is not uncommon for members of the DC-based National Symphony Orchestra to perform with the Go-Go Symphony to get a taste of the DC sound.

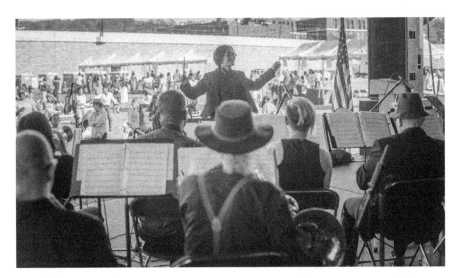

Liza Kravinsky conducts the Go-Go Symphony at Anacostia Park.

Go-go culture recently found its way into DC's theatrical scene with two musical productions selling out theaters in the city. In November 2016, Georgetown University Theatre and Performance Studies Program, along with the DC Mask and Bauble Dramatic Society and Black Theatre Ensemble, presented *Wind Me Up, Maria!* a go-go interpretation of Rodgers and Hammerstein's *The Sound of Music*. With Rare Essence's Charles "Shorty Corleone" Garris as co-creator and director, the stage production featured a live go-go band consisting of Garris, Milton Freeman, DonJuan Staggs and more. The story centered on a young woman, Mary, from Southeast DC, who is short on tuition money and accepts a position looking after the six children of Professor Sherry Kalorama for the summer. Mary then schools the children on the music of go-go and its importance to DC. The production highlighted themes of income inequality, gentrification, gender identity and more while mixing in go-go classics like Chuck Brown's "Run Joe" and others. The climax of the production was when the ghost of Chuck Brown appeared and shared his wisdom with the characters, making everything all right. Chuck Brown's sons Wiley and Nekos Brown consulted with the actor who portrayed the Godfather of Go-Go on mannerisms, style and speech patterns, which allowed the actor's portrayal to look, sound and feel like Chuck Brown. The musical had a run of sold-out performances with an extra sold-out performance added at the Davis Performing Arts Center located on Georgetown University's campus.

Two years later, in the late summer of 2018, producer Dr. Lovail M. Long and Salahuddin Mahdi, along with director Lovail M. Long Sr., formed a production company, DC Black Broadway, to produce the go-go musical *The Giz*. *The Giz* was an interpretation of Motown's 1978 movie *The Wiz*, which itself was an urban interpretation of Metro-Goldwyn-Mayer's 1939 classic film *The Wonderful Wizard of Oz*. The new film starred go-go stars Frank "Scooby" Marshall as the Cowardly Lion and Gregory "Sugar Bear" Elliot as the Giz. Chuck Brown's daughter KK Donelson, Anwan "Big G" Glover, DJ WPGC's Tony Redz and Deejay Flexx also had roles in the production.

The play followed the lead character, Dotti, who had long dreamed of attending Howard University, as she was swept up by a tornado and landed at the border of Prince Georges County and Washington, DC. She then followed the yellow brick road to get to Howard University, dealing with gentrification and other issues and learning about Washington, DC's go-go along the way. The Wicked Witch character is played as a gentrifier who casts roadblocks throughout Dotti's passage. On Dotti's journey, she begins to become familiar with DC's go-go culture and music. Frank "Scooby" Marshall's band Sirius and Company was the house band, and Milton "Go-Go" Mickey and his two sons, Brion "BeeJay" Scott and Mikey "L'il Mick" Freeman, all had percussive roles.

The show opened to a sold-out house on August 19, 2018, at the three-thousand-seat MGM National Harbor. The play went on to win many awards, including Film/Production of the Year at the Titan awards, Best Play at the Social Media East Coast Awards, Play of the Year at the Play Magazine Awards and the Go-Go Preservation Award at the 2019 Go-Go Awards.

Tim Okamura, a world-famous portrait artist who specializes in painting African American women in their career roles, came to DC for three years to paint DC women specifically, and in the fall of 2013, he rolled out over a dozen life-size paintings at a gallery on U Street. Featured in two of those paintings were go-go artists Natasha "MzLaydee" Kelly and conga player Natarsha "Lil Boogie" Proctor.

Go-go originated from kids playing buckets and pans on the street, and while it moved to the clubs and then onto the charts, the street corners of DC still remain alive as bucket drummers, full-on go-go bands and Beat Your Feet dancers play for singles, tens and twenties every day in the city and, recently, in the Maryland and Virginia suburbs. Travisty Gardiner's popular street band the Experience Band and Show incorporates a go-go

Natasha "MzLaydee" Kelly in front of Tim Okamura's life-size painting of her at the gallery opening of his show depicting working women of DC World.

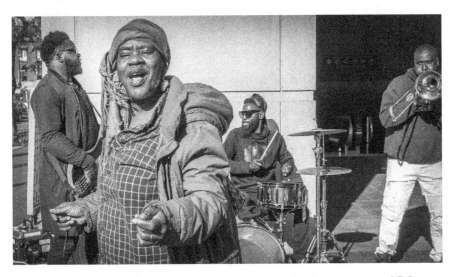

The Experience Band performs regularly on the corners in the downtown area of DC.

A bucket drummer is packed up from a day of busking in front of the White House.

medley into its corner performances around the city, with office workers grooving to the music but not having any idea that that beat and groove is go-go. The same is true for many baseball fans who dance to Chuck Brown's "Bustin Loose" each time a home run is hit at a Washington Nationals baseball game.

THE ARTISTS

CHUCK BROWN

I'm just going to say this right here; around DC, Chuck Brown is known simply as "Chuck." That's all. Everyone knows this. If you say, "I saw Chuck last night," everyone knows what you did last night. There is one other person in DC's music history—Chuck Levin, the founder of Chuck Levin's music store—who is also referred to as just "Chuck." In the DC vernacular, when someone says, "I'm heading up to Chuck's," everyone knows exactly where they are going. There is never any explanation needed when it comes to either Chuck. That's just DC.

Chuck Brown was born on August 22, 1936, in Gaston, North Carolina, to an absent father and a struggling mother. Chuck was born into poverty. Moving to Washington, DC, at just six years of age, Chuck fended for himself by shining shoes up and down U Street, then known as the "Black Broadway." It is said that he shined the shoes of the great performing artists of that time, including Duke Ellington and Count Basie, in front of the famed Howard Theatre.

By his mid-teens, Chuck was living on the streets of DC, hustling whatever he could from petty crime to back-alley boxing, where local gamblers would pay bareknuckle teens to fight it out while those in attendance would wager on the fight.

In the mid-1950s, Chuck found himself in Lorton Penitentiary doing an eight-year stretch for second-degree murder. While in Lorton Penitentiary,

Chuck swapped cigarettes for a guitar and learned to play it. When he was released, he was determined to shift his life in a better direction, with music guiding that path.

While playing with local DC bands of multiple genres, Chuck worked as a bricklayer, truck driver and even a sparring partner during the day. Soon, Chuck formed his own band, the Soul Searchers, and began creating his own original sound. The sound he created and called go-go soon caught on with not only his band but other bands in the DC area as well (see chapter 1).

With the Soul Searchers, Chuck went on to score hits such as "We the People," "Blow Your Whistle" and "We Need Money." His largest hit was 1979's "Bustin Loose," which charted at number one on *Billboard*. With "Bustin Loose" charting, Chuck and his band toured all over the country and made appearances on the popular television show *Soul Train*. While touring the country, Chuck stayed true to his local DC fan base, making it back to DC regularly to play the local clubs. He also was known to pass advice on to younger bandleaders, letting them know that worldwide fame may come to them for a while, but your true fans are in DC.

A twenty-second drum break from the Soul Searchers' instrumental song "Ashley's Roach Clip" off the 1974 album *Salt of the Earth* has become one of the most highly sampled tracks in songs of all genres. Run DMC, LL Cool J, Milli Vanilli, Kid Rock, Lynyrd Skynyrd, Vanilla Ice and Slick Rick are just a few of the hundreds of artists who sampled this drum break.

Outside of go-go, Chuck is also known for his recordings with the then unknown jazz, folk and blues singer Eva Cassidy. Chuck had first become aware of the shy singer when producer Chris Biondo shared a few recorded tracks with him. Chuck had always wanted to record the jazz standards that were the first songs he learned to play on his prison guitar. With an ensemble of DC's finest musicians and Biondo producing, Chuck and Eva recorded the album *The Other Side*, which included fourteen tracks of jazz songs, many sung as duets. The album was released in 1992 on Tom Goldfogle and Becky Marcus's Liaison Records. It was the only studio recording released by Eva Cassidy before her untimely death at thirty-three years of age from a sudden recurrence of cancer. The album included her version of "Somewhere Over the Rainbow," which has become the song she is most known for. Following her passing, Eva Cassidy gained worldwide attention through the release of a dozen studio albums she had recorded prior to her death. The last album she recorded, *Live at Blues Alley*, went on to sell in excess of ten million records. In 1998, Chuck released a second album of jazz standards, *Timeless*, devoted to Eva Cassidy.

Staying true to his own advice, Chuck maintained a vigorous schedule of playing locally, traveling outside DC and releasing studio albums as well as live albums for the rest of his life. His live album of one of his famous go-go star-studded birthday parties, *Your Game...Live at the 9:30 Club*, has been ranked in the top one hundred live albums by the editors of *Rolling Stone* magazine.

Chuck was also known as having one of the best bands and best-paid bands in DC. Chuck often spoke about his management style and would tell the younger bandleaders to hire the best young talent in town and pay them well. Have them play hard and strong like they were going places. The minute a member of his band plateaued, became cocky or began to slack off, Chuck would replace him with a younger, more ambitious musician. He would often do this by having the replacement musician show up for a show, and then he would say to the musician he was about to fire, "Man, I love how you play for me every night. I love looking over at you, seeing you play your solo. That's why I'm gonna miss you." The replacement musician would finish the show. Many of his band members were fired several times.

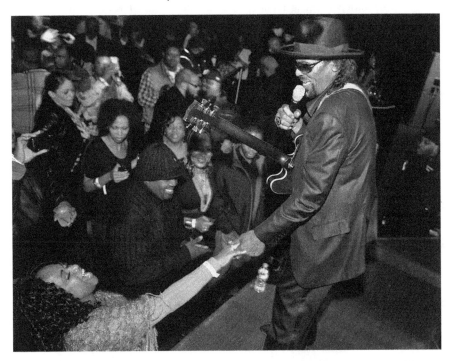

Penny Braxton (Chuck called her Chinchilla) and Kevin Jones rarely missed a show. Here, Chuck Brown holds Penny's hand during a performance at the Love nightclub while Kevin (in the black knit cap) looks on.

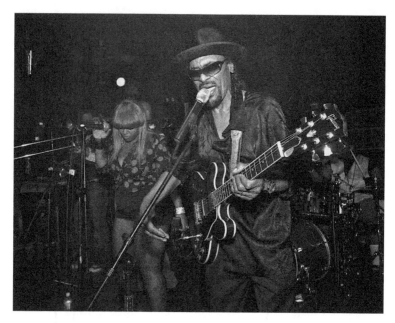

Chuck Brown performing at Fur Night Club with daughter KK by his side. This was one of his final shows.

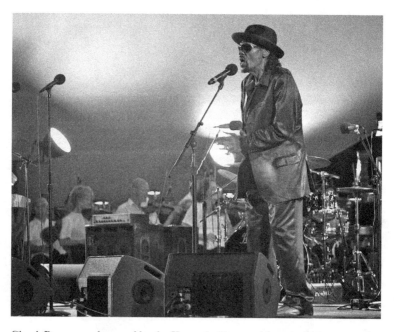

Chuck Brown was honored by the Kennedy Center with an invitation to perform on the West Lawn of the National Capitol with the National Symphony Orchestra, followed by a full performance with his band in front of fifty thousand fans.

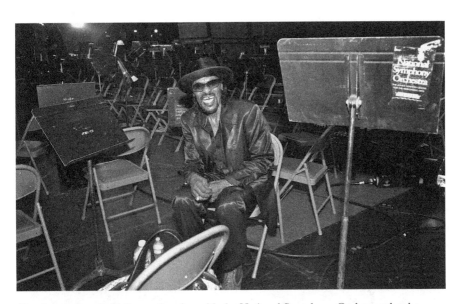

Chuck was so excited after performing with the National Symphony Orchestra that he could hardly sit down and rest following the show.

Chuck Brown always chewed on a lemon prior to each show.

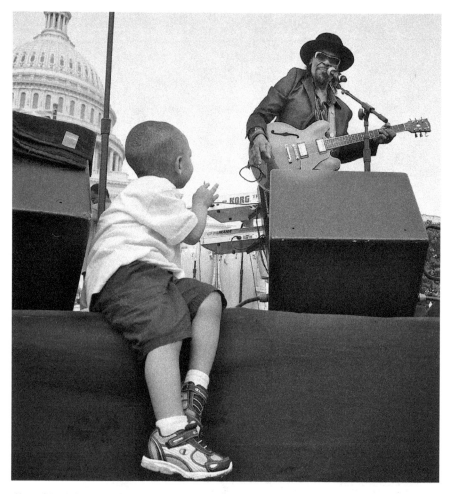

Above: Chuck Brown always took time to encourage younger folks to pursue their music. Here, Chuck shares a moment with a toddler while performing at a rally for DC statehood on the grounds of the U.S. Capitol.

Opposite, top: Chuck Brown confers with his drummer Kwickfoot prior to a show.

Opposite, bottom: Chuck was known to sign autographs until the last people left the venue. Chuck Brown and daughters KK and Cookie sign autographs following a benefit show for DC statehood on the grounds of the U.S. Capitol.

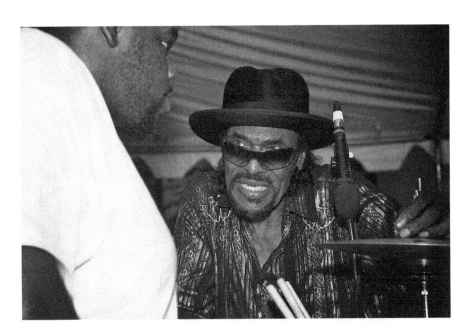

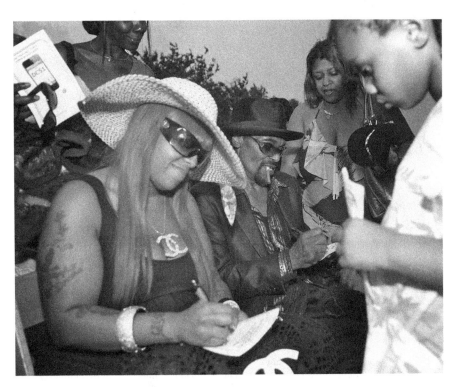

Chuck Brown was all smiles as he visited with his family in his trailer prior to his guest appearance on the West Lawn of the U.S. Capitol.

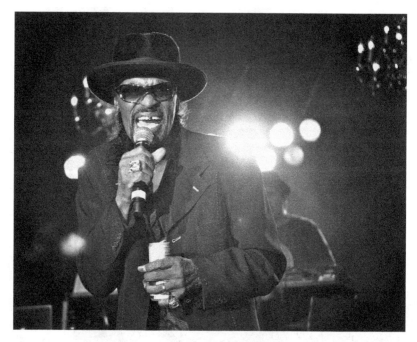

The crowd went crazy when Chuck Brown stepped onstage with DC-based band Thievery Corporation and performed "The Numbers Game," a song that Chuck had written and recorded with Thievery Corporation founders Eric Hilton and Robert Garza.

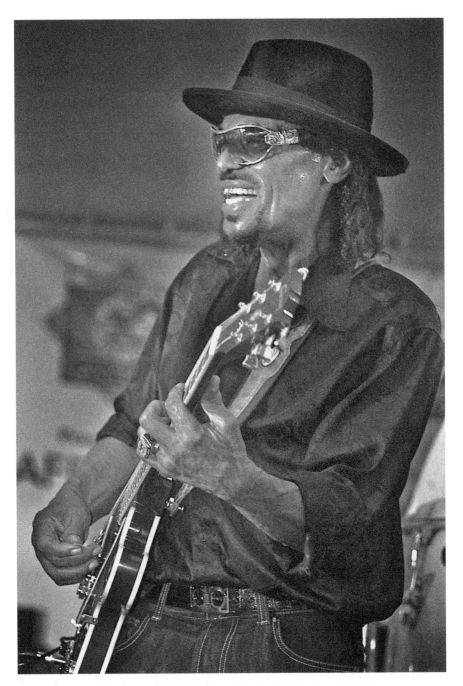

Chuck Brown performing at the DC Barbeque Battle, which he headlined for many years.

The final year in which these photos were captured was a year of honor for the Godfather of Go-Go. Chuck Brown had a street named after him and was nominated for a Grammy for his duo with Jill Scott and Marcus Miller called "Love," but Chuck's shining moment came on Labor Day weekend, when he was honored on the West Lawn of the United States Capitol by the National Symphony Orchestra. He performed several of his songs in an orchestral arrangement. Following this performance, Chuck and his band, along with Sugar Bear and Doug E. Fresh, continued the performance in front of fifty thousand fans.

Chuck Brown passed away on May 16, 2012 (see chapters 7 and 8).

D. FLOYD

One of the most influential musicians in go-go is Donnell Floyd, known onstage as D. Floyd. Donnell joined Rare Essence while still in high school at Duke Ellington School of Performing Arts. He joined the band as a saxophone player but soon moved up to the microphone and became not only front man but also a force in songwriting and composition. "If you were singing or dancing to it in the '80s or '90s, chances are pretty good that I wrote it," he once said.

Donnell stayed with Rare Essence through the late '90s. It was at that time that Rare Essence made an out-of-court settlement with Jay-Z over the use of one of their songs, "Over Night Scenario," which Donnell had written for Rare Essence. When Donnell asked for a part of the settlement, Rare Essence management told him that he "wasn't part of the publishing arm of the organization."

Setting out on his own, Donnell started his own band. He originally called the band 911 but soon changed the name following the events of September 11, 2001, to Familiar Faces. At the beginning of the time that these photos were taken, Donnell's Familiar Faces band was not active on the go-go circuit. Donnell had been asked to join Chuck Brown's band following the sudden death of Lil Benny. Following a Rare Essence reunion show in late 2010, Donnell began performing again with Rare Essence, but that only lasted for a few months.

In November 2011, after Familiar Faces had taken a brief hiatus, Donnell made a major move in go-go by re-forming Familiar Faces with go-go's hottest talent. Joining Familiar Faces was Frank "Scooby" Marshall, Jasen "O" Holland and Kenny "Kwickfoot" Gross from the band Lissen and

Right: D. Floyd is about to "check the clock," one of the few times go-go music stops for a few beats while everyone in the house freezes and checks their watches for a few beats.

Below: D. Floyd and Jasen "O" Holland performing with Familiar Faces at Society Lounge.

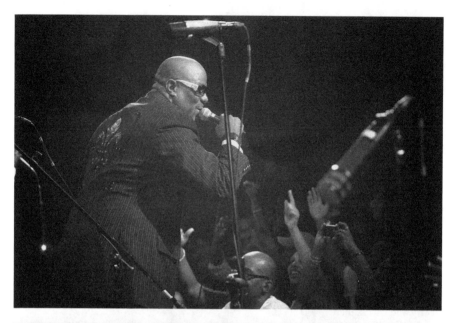

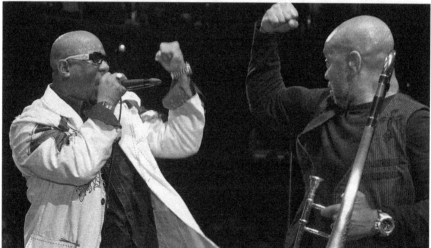

This page, top: D. Floyd performing with the Chuck Brown Band at the Howard Theatre.

This page, bottom: D. Floyd and Greg Boyer performing Floyd's version of Biggie Smalls's "Warning," always a fan favorite, with the Chuck Brown Band at the Howard Theatre.

Opposite, top: D. Floyd holds a microphone to the audience for their response at a Chuck Brown tribute at Meriwether Post Pavilion.

Opposite, bottom: D. Floyd leading Familiar Faces. *Left to right*: Quiesy, D. Floyd, Ms. Kim, Scooby and Marcus Young.

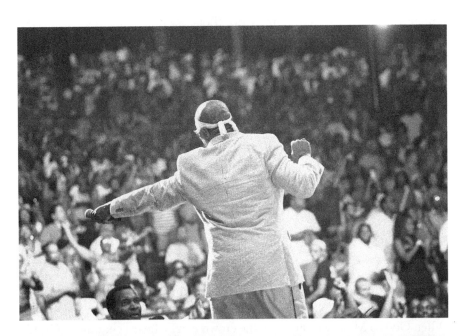

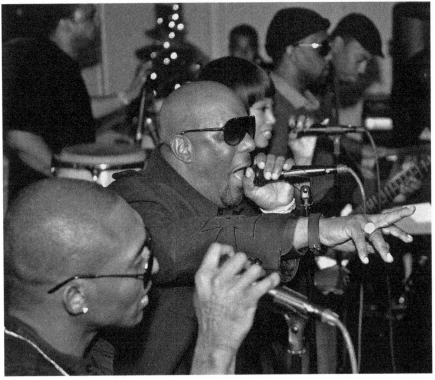

Kimberly "Ms. Kim" Graham, Eric "Bojack" Butler and Derrick "DP" Paige from Rare Essence. A little over a year later, Milton "Go-Go Mickey" Freeman and Byron "BJ" Jackson (RIP), also from Rare Essence, joined the band. With all this talent in one band, Familiar Faces stepped into the go-go circuit as DC's hottest band, where they remained for nearly six years.

After making some significant band changes in 2017, Donnell "D" Floyd retired from go-go to pursue other musical pursuits with an all-star, sold-out sendoff concert at the Wharf's Anthem Concert Hall. Stevie Wonder arrived unannounced and played two songs with the band in D. Floyd's honor.

GO-GO MICKEY

Conga player Go-Go Mickey is known throughout go-go as "The GOAT." He played briefly in a few bands before joining Rare Essence, where he stayed for twenty-six years, before leaving in 2013 to join Familiar Faces. When Go-Go Mickey is on stage, the crowd can be heard chanting, "Go-Go Mickey! Go-Go Mickey!" Not only has he made his stamp on the genre, but he has seen that his stamp will carry on for future generations, as two of his sons, BeeJay and L'il Mick, are now grown and playing in go-go.

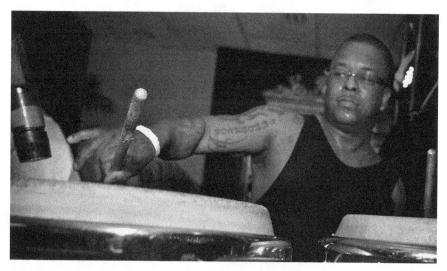

The GOAT, Go-Go Mickey, cranking with a drumstick on a conga drum to get that authentic go-go sound.

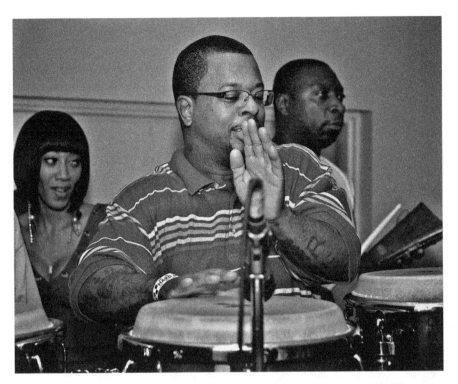

Go-Go Mickey doing what he does best: slapping the congas at rapid speed. Ms. Kim and Bojack can be seen behind him.

MAIESHA RASHAD

One of the most critical shifts in go-go music that would ultimately move it in a new direction began when Maiesha Rashad came onto the club scene in the mid-'90s and formed her own band, Maiesha and the Hiphuggers. Maiesha and the Hiphuggers originally began as a soul band geared toward a mature crowd, playing mostly covers of popular soul songs from the '60s and '70s. Go-go fans had matured, and shortly after forming the band, Maiesha added members of Experience Unlimited—drummer David "JuJu" House, bass player Gregory "Sugar Bear" Elliot, keyboardist Cherie "Sweet Cherie" Mitchell-Agurs and conga player Maurice "Mighty Moe" Hagans—to her band. The band still played popular cover soul songs but now adapted the go-go beat and deep pockets and kept the music going continually throughout the show. This new blend of popular cover songs played in go-go style, created by Rashad, came to be known as "grown and

Maiesha and the Hipphuggers band manager Adriane "Dre Dre" Burkley with drummer Kwickfoot.

Maiesha Rashad performs at one of Maiesha and the Hiphuggers' last performances at La Fontaine Bleue in 2016.

sexy," which caught on with maturing go-go fans as well as newer fans. "Grown and sexy" allowed promoters to bring go-go bands into more sophisticated, upscale clubs, many of which required an upscale dress code. Working with band manager Adrianne "Dre Dre" Burkley, Maiesha and the Hiphuggers rapidly climbed to become the number-one band in the city, playing seven nights a week and often ten gigs each week.

Because of its popularity, many bands began to adopt the "grown and sexy" subgenre of go-go music. In the twenty-five years since its start, "grown and sexy" became and still is the number-one subgenre in go-go. As of this writing, playing cover songs in go-go style remains the most popular form of go-go for both fans and bands.

Maiesha Rashad passed away in June 2020 from stomach cancer, but her legacy remains a very important part of the history of go-go and the history of Washington, DC, not only because of her creation of the "grown and sexy" style, which allowed go-go to revive itself and grow as fans aged, but also because she was the first woman in go-go not only to front her own band but also to lead her own band, which opened the door for many women in go-go.

Some argue that while the "grown and sexy" style of go-go allowed the genre to grow its audience locally and sustain itself financially for many years, relying on cover songs has hampered the growth of go-go into wider markets and national audiences because of copyright law and lack of originality. Many of the bands play the same songs, and it has become rare in recent years for go-go bands to write, produce and record original music to take to a wider audience.

The two pioneers of go-go who broke the glass ceiling for women in go-go: Ms. Kim and Maiesha Rashad.

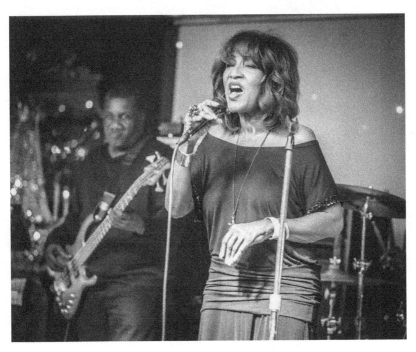

Maiesha Rashad hits her notes at one of Maeisha and the Hiphuggers' last shows. Bassist Sugar Bear looks on.

MS. KIM

One day, a young Kimberly Graham went to a Rare Essence show with her girlfriends to celebrate one of their birthdays. Midway through the party, her girlfriends urged her to jump up on stage and sing happy birthday to her friend. Go-go history took a turn on this day, as Kimberly Graham was immediately asked to join the band as a frontline singer. She adopted the name Ms. Kim and became one of the first female frontline singers in a go-go band. Her 2005 hit, a go-go rendition of Ashley Simpson's "Pieces of Me," was in heavy rotation and still is today on DC radio stations.

Ms. Kim performing with Familiar Faces at Love Night Club.

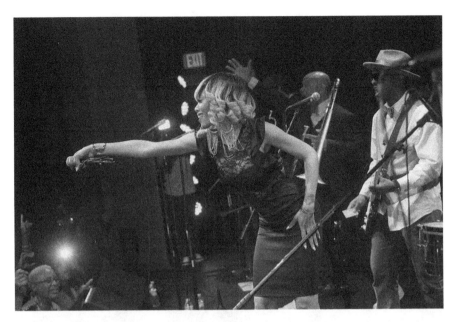

Ms. Kim performing with the Chuck Brown Band at the Howard Theatre. Scooby and Greg Boyer can be seen in this photo.

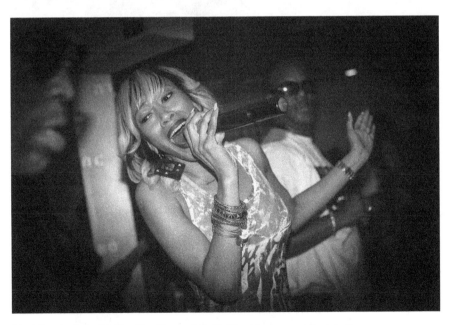

Ms. Kim singing with Familiar Faces while D. Floyd looks on at Society Lounge.

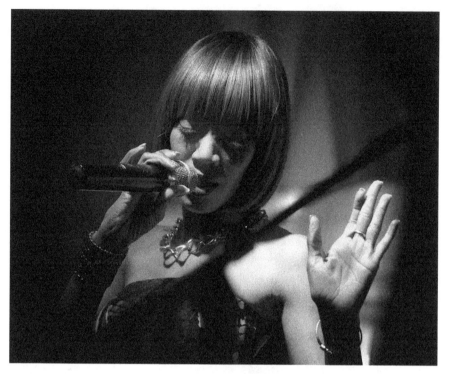

Ms. Kim singing with Familiar Faces at the Hampton Conference Center.

Ms. Kim stayed with Rare Essence for fifteen years. She spent a brief time performing in Atlanta, toured nationally with Raheem DeVaughn and then returned to DC to join D. Floyd and Familiar Faces.

In the time since Ms. Kim joined Rare Essence, just about every go-go band has had a female singer on the frontline. Ms. Kim broke the glass ceiling in go-go, opening the doors for female singers.

CHERIE "SWEET CHERIE" MITCHELL-AGURS

Sweet Cherie may be best known as Chuck Brown's longtime keyboard player and vocalist, but her place in go-go is so much more than that. Coming out of DC's Duke Ellington School of Performing Arts, Sweet Cherie attended Oklahoma City University, Virginia Commonwealth University and Howard University and graduated with a bachelor's degree cum laude. Cherie has perfect pitch. She played a huge role in bringing out the grown and sexy style with Maiesha and the Hiphuggers. Following that,

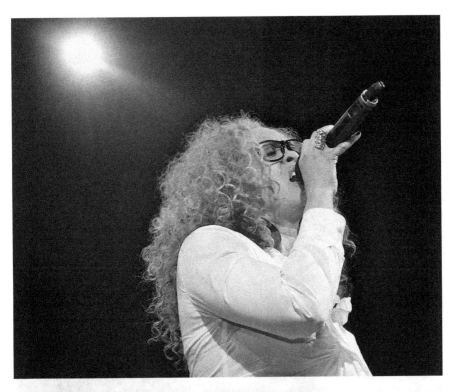

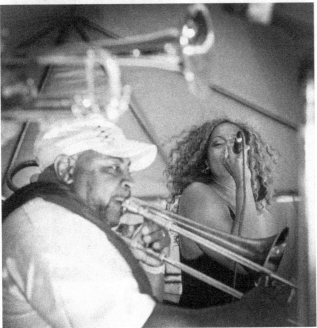

Above: Sweet Cherie performing at the Howard Theatre with the Chuck Brown Band.

Left: Sweet Cherie performing with the Chuck Brown Band at DC's annual Barbeque Battle with Leon Rawlings on trombone.

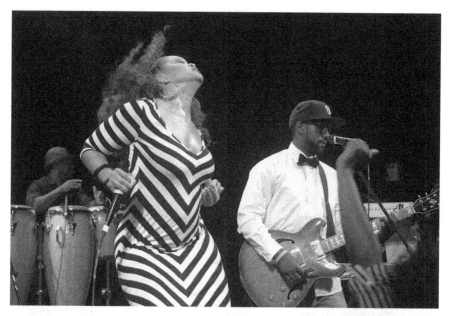

Sweet Cherie along with Scooby perform with the Chuck Brown Band at Howard Theatre.

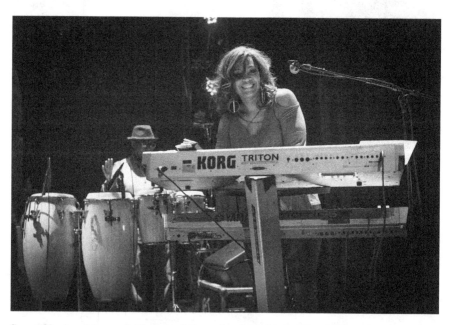

Sweet Cherie soloing on keyboards while performing with the Chuck Brown Band. Mighty Moe keeps the beat on congas.

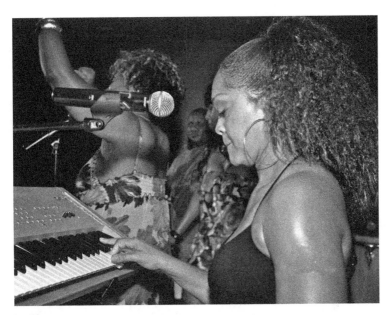

Sweet Cherie is seen here playing keyboards with Bela Dona at My Place Sports Bar. Also in this photo is DaMilla Adams singing, with Sugar Bear and Wendy Rai on stage as well.

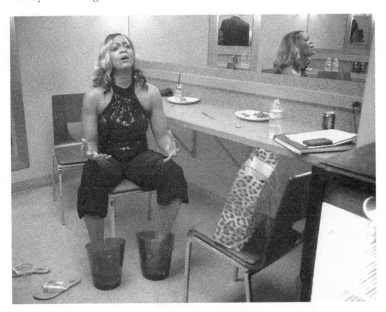

Go-go is not all glam and glitter. Many artists often play five to eight gigs a week. The ladies of go-go perform in six-inch-high heels. Here, Sweet Cherie soaks her feet in ice buckets backstage at the Howard Theatre following a performance there.

she performed regularly around DC with Experience Unlimited. Cherie also toured the world with band Pieces of a Dream and Nile Rodgers's band Chic. In the late 2000s, Cherie assembled an all-female go-go band known as Bela Dona. This band became huge on the go-go circuit, playing four to six nights a week. She and her husband, John Agurs, also run a studio, backline and livestream performance space popular with many go-go bands and DC bands of other genres.

SUGAR BEAR

Gregory "Sugar Bear" Elliot's band Experience Unlimited (EU) was one of the early bands to adopt the go-go beat and one of the few to take it to a national level. The singer and bass player is known for his crisp signature use of the word "Owww" while performing in front of the crowds of DC. International fame came to Sugar Bear when Spike Lee approached him and his band about recording and performing a song called "Da Butt," written by Marcus Miller, in his movie *School Daze*. The song hit number

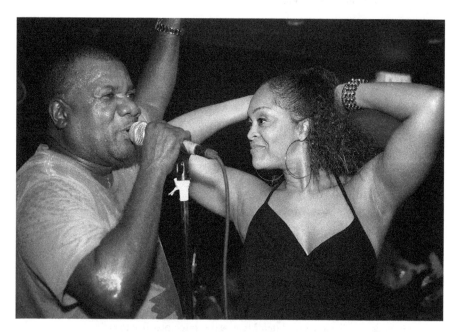

Sugar Bear is often a guest star when Bela Dona performs. Here he is with Sweet Cherie performing his hit "Um Bop Bop" at My Place Sports Bar. The evening temperature outside that night was 101 degrees; it was hotter in the club.

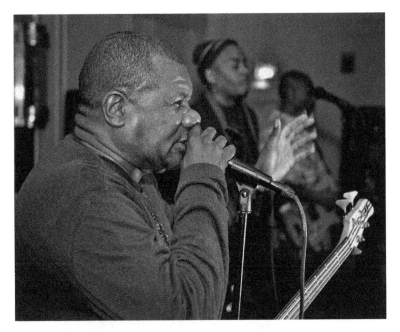

Sugar Bear performing with Experience Unlimited at the Sheraton.

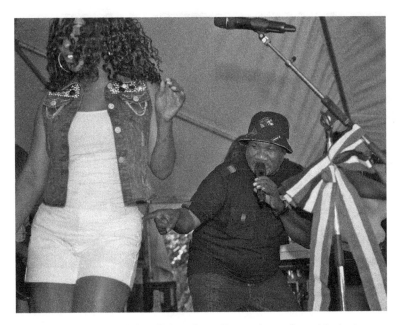

"Wendy Rai got a big ole butt," sings Sugar Bear as he performs his chart-topping hit at DC's annual Barbeque Battle.

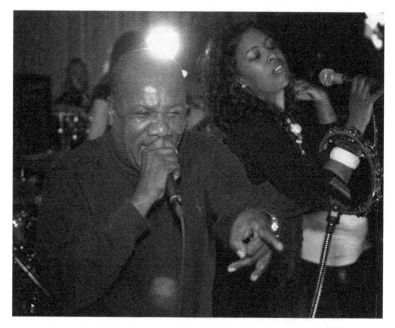

Sugar Bear doing a guest appearance with Bela Dona at La Fontaine Bleue. Wendy Rai is seen behind him.

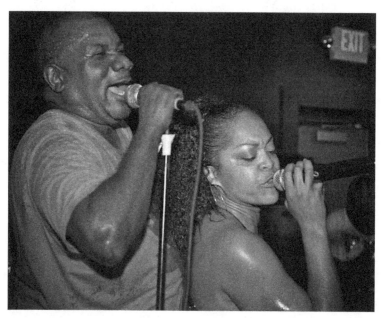

Sugar Bear performing his hit "Um Bop Bop" with Sweet Cherie at My Place Sports Bar. The temperature in the bar was well over 105 degrees.

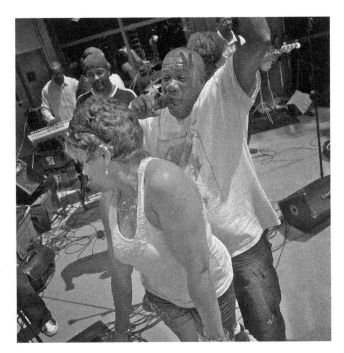

Sugar Bear dancing with fan Crickett Harris while making a guest appearance with Faycez U Know at the Anacostia Community Museum. Singer Kal-El Gross can be seen behind them.

one on *Billboard*'s Hot Black Singles Chart in 1988, and the video, directed by Spike Lee, gained heavy rotation on MTV. Sugar Bear and EU traveled the world over, gaining fans worldwide.

For decades, Sugar Bear has taught special education students at Alexandria, Virginia's famed (as seen in *Remember the Titans*) T.C. Williams High School.

While go-go has brought international fame to Sugar Bear, he will tell you that musically he loves the old rock-and-roll. He can often be seen performing in Jimi Hendrix T-shirts, and occasionally his band will kick a rock-and-roll guitar lick into their performance.

When not performing with Experience Unlimited, Sugar Bear hits the go-go scene almost nightly, doing walk-on special guest appearances with Bela Dona, Rare Essence, the Chuck Brown Band and several others.

KK

Chuck Brown's daughter Takesa "KK" Donelson is one of go-go's best-known rappers. Performing regularly since an early age with her father and his band, KK is known for her sharp-tongued, on-point raps that she brings

Chuck Brown's daughter KK lends a hand to her father by toweling him off during a 2010 performance at the former Lorton Penitentiary, where Chuck served his sentence.

KK raps on the microphone while performing with the Chuck Brown Band during a Chuck Brown tribute at Meriwether Post Pavilion. Sax player Bryan Mills also appears in this photo.

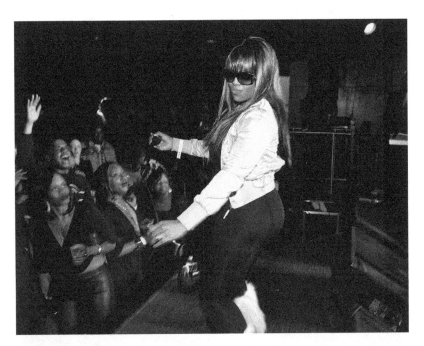

KK performs in style at Love nightclub.

KK always makes her preshow dressing room arrivals in style.

to the stage. KK does not hold back. When she hits the stage midpoint in a Chuck show, she takes the whole show to a much higher level of energy. She also brings to the stage her own funky wardrobe. While performing with her father's band is her main gig, KK can be seen around town regularly performing with bands such as Bela Dona, Backyard Band and others.

KACEY WILLIAMS

When Kacey hits the stage for a performance, she owns it. Period. End of story. Kacey Williams fronts the rock funk soul go-go band Back Alley, which combines all these genres into a high-energy, action-packed stage performance driven over the go-go beat. Professionally trained in voice, Kacey has a tremendous vocal range, which she capably demonstrates at each performance. Kacey began singing publicly in her church. From an

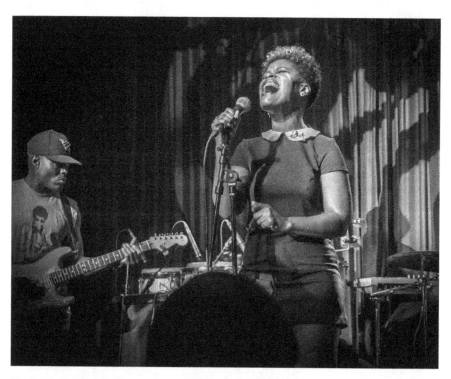

Black Alley's Kacey Williams sings her heart out the night before Black Alley went to Prince's Paisley Park and won the Musicology Battle of the Bands.

Black Alley's Kacey Williams performing at the Fillmore.

Chuck Brown chose Black Alley to open for him at what became his final birthday party show at the 9:30 Club. Kacey Williams sings at that party.

Kacey Williams captures the audience while performing with Black Alley at the Howard Theatre.

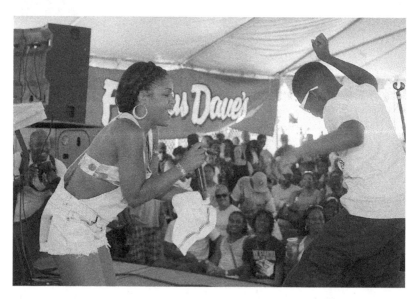

Black Alley's Kacey Williams brings a young Sammie Powell up onto the stage at the Barbeque Battle to show his moves, which Sammie did very well. Sammie's family can be seen in the front row; that's Sammie's mother holding the coffee.

early age, she trained in dance and become the captain of her step troop at Roosevelt High School. She not only brings her vocal and dance moves to the stage, but she also extends her style onto the stage with her fashion sense to reach the audience and hold their hearts in her hands as she leads them through the show. On stage, she is a force, she is a dynamo. Before she takes the stage, Kacey often sits alone, away from everyone, in a quiet, meditative state, pauses for a moment on the stage steps, hits the steps and lights the stage afire.

WENDY RAI

Like many female vocalists in go-go, Wendy Rai Rothmiller began singing in church. After being reluctantly recruited to sing in Unwine Band for a few gigs, Wendy caught the eye of Bela Dona's manager, John Agurs. Wendy began singing in the frontline of Bela Dona. She left Bela Dona briefly for

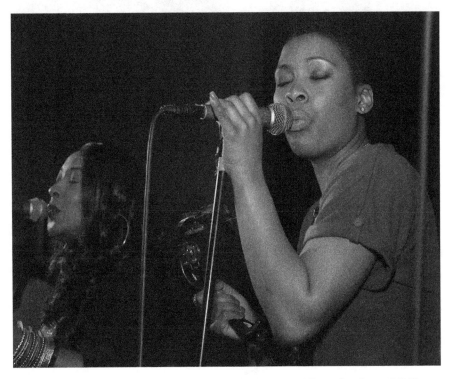

Wendy Rai and Bela Dona lead talker Karis Hill harmonize while performing at My Place Sports Bar.

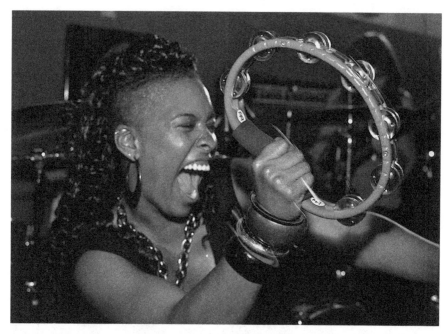

Wendy Rai is known for her explosive tambourine playing while performing with Bela Dona.

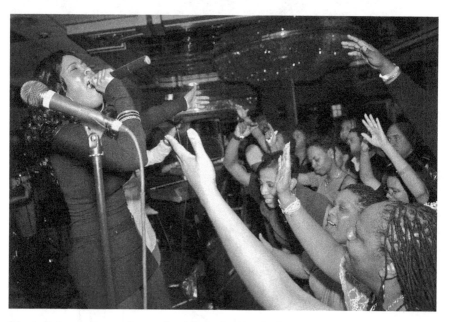

Wendy Rai stays close to the people while performing for Bela Dona at La Fontaine Bleue.

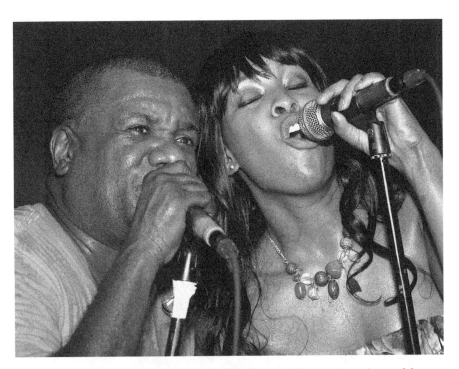

Sugar Bear and Wendy Rai performing with Bela Dona in 105-plus-degree heat at My Place Sports Bar.

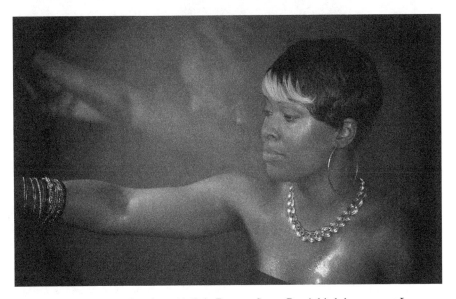

Wendy Rai and Bléz performing with Bela Dona at Sugar Bear's birthday party at La Fontaine Bleue.

a short stint with Suttle Thoughts and then found her band home with Bela Dona for the remainder of her go-go career. By day, Wendy is a firefighter with the Montgomery County, Maryland Fire Department, but Wendy is also known as an actor in DC's local theater community as well as a cover model for paperback books. During her time in go-go, Wendy also learned how to DJ. Wendy left go-go in 2014 to start a family, and today, she runs a DJ company with a half dozen DJs, works as a firefighter and is a mom.

JAS FUNK

Deep back in the formative times of go-go, in the mid-'70s, James "Jas Funk" Thomas was a popular DJ whose mother managed a few young bands that played around town. Upon his arrival in go-go a few years later, "Jas Funk" would perfect the role of lead talker. He was known as a disco DJ. At the urging of several "street DJs," Funk began speaking on the microphone

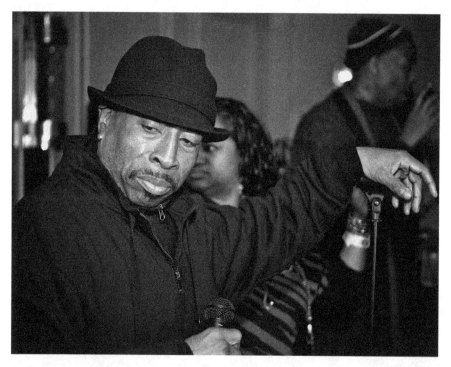

Jas Funk takes a contemplative pause for a moment while performing with Rare Essence at the Sheraton.

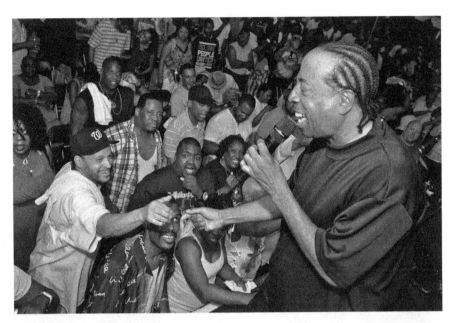

Jas Funk performing with the Chuck Brown Band at the annual Barbeque Battle. Chuck fan Kevin Jones can be seen in the compositional center of this photo.

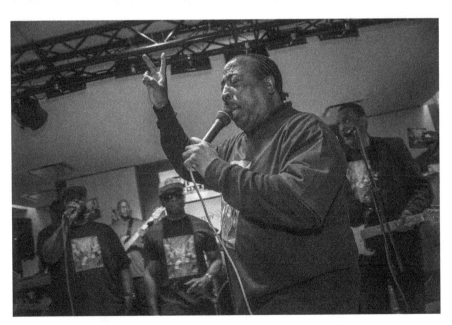

Jas Funk performing in his role as lead talker with Rare Essence at the WPGC studio in Southeast DC. The Rare Essence frontline, *left to right*, is made up of Killa Cal, Shorty Corleone and White Boy.

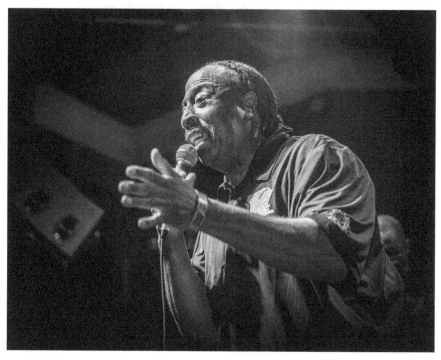

Jas Funk performing with Rare Essence at Cool Disco Dan's homegoing at the 9:30 Club.

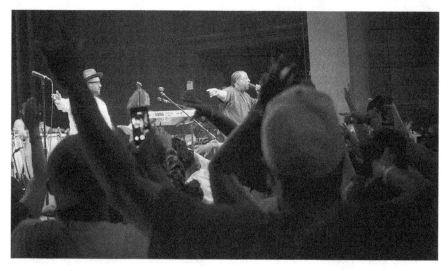

Jas Funk winding up the audience with the Chuck Brown Band at Chuck's 2014 birthday party at the Howard Theatre, which followed the dedication of the Chuck Brown Park earlier that day.

while the music played, which, when done well, could engage the audience and keep the party going. As the words started to roll off his lips and tongue, the more popular he became in the party circuit. Around this time, one of the bands that his mother, who was known around the DC music scene as Ms. Mack, managed, the Young Dynamos, began rehearsing at their home. Funk took a liking to this younger band and started offering them his advice, and because of his popularity as a DJ, the young band members listened carefully and began to look up to him. A few years later, when the band moved on from being primarily a funk cover band, adopted the go-go beat, changed their name to Rare Essence and gained some popularity, Funk began performing with Rare Essence on the microphone as their lead talker. With Jas Funk in this role, Rare Essence became the leading band of the go-go circuit and has remained in that position for over forty-five years.

In later years, Jas Funk started his own band, Proper Utensils, which dedicated itself to "old-school go-go."

JUJU

While go-go has some of the most talented drummers, one of the most extraordinary drummers is William "JuJu" House. The longtime drummer for Experience Unlimited, JuJu has also played in bands Maiesha and the Hiphuggers, Chuck Brown and the Go-Go Symphony. However, while JuJu

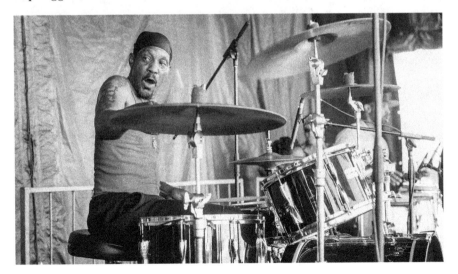

JuJu Performing with the Go-Go Symphony in Anacostia Park.

Top: JuJu performing with Experience Unlimited at Haydee's Restaurant.

Bottom: JuJu performing with Experience Unlimited at La Fontaine Bleue.

Conductor Liza Kravinsky holds the flap open as JuJu leaves the dressing room tent for the stage prior to a performance of the Go-Go Symphony in Anacostia Park.

drives the go-go beat in DC, many of his days involve riding the train to New York City, where he is one of the most sought-after studio session drummers in the country. JuJu has recorded with Miles Davis, Grace Jones, Eva Cassidy, Roberta Flack and many other national artists. He is adamant about passing the beat down to the next generation and participates actively in Experience Unlimited's original manager Charles Stevenson's Teach the Beat nonprofit, which not only advocates for the teaching of go-go in DC schools but also brings go-go musicians into the classrooms.

SCOOBY

Vocalist, guitar player and bandleader Frank Marshall/Scooby/Frank Serius is known around DC as Scooby, Frank Serius and the Go-Go Godson; his friends just call him "Mister AKA." Frank came from a musical family. He attended Eastern High School, known for its famous marching band, where his father was the musical director. It was in high school that Frank began playing in local go-go bands around the Capitol Hill neighborhood where he grew up. He and some high school friends joined together to form

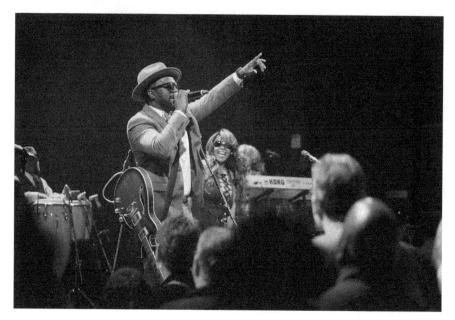

Frank "Scooby" Marshall performs with the Chuck Brown Band at the Howard Theatre.

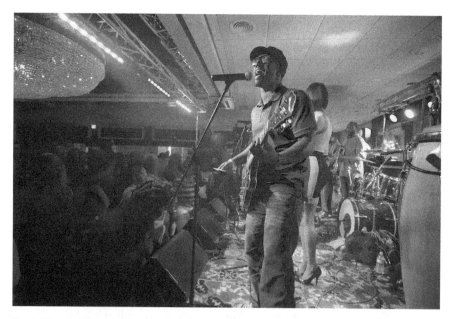

Frank "Scooby" Marshall, using his signature credit card guitar pick, performs with Familiar Faces at La Fontaine Bleue.

Frank "Scooby" Marshall takes a contemplative moment prior to one of his first appearances in the Chuck Brown Band, where he stepped into Chuck Brown's role with the band. The author/photographer can be seen in the mirror.

the band Lissen, which at the time it started was more of a vocalist band. Following a band member's death, they tightened up their sound, adapted more of the go-go sound and became DC's hottest go-go band for a run of a few years. Their song that Frank wrote with Uno, "Sunshine," became a local hit. The Lissen Band disbanded in 2011, and Frank and longtime band member Jason Holland—known simply as "O"—joined Familiar Faces. For several years, one of Frank's nicknames became the "Go-Go Godson," a title bestowed on him by go-go songwriter and producer Uno, who was cowriting not only with Frank but many in go-go at the time. Upon the passing of Chuck Brown, Frank stepped into that nickname and began fronting what became the Chuck Brown Band. His signature style is to play guitar using a credit card in place of a guitar pick.

BIG G

Anwan Glover, aka Big G, aka Genghis, aka the Ghetto Prince, aka Slim Charles, entered DC's go-go scene in the late '80s as one of the founders of the Backyard Band (aka BYB, aka Back). In the Backyard Band, Anwan takes the role of lead talker and rapper. The band is known for combining rap and bounce beat into its music. Anwan Glover is also a well-known actor

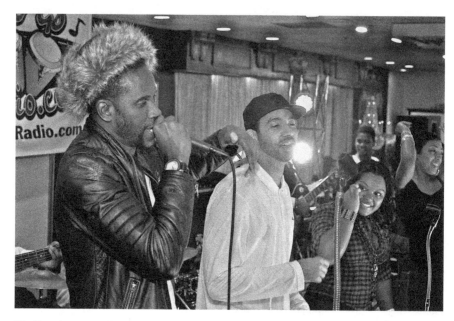

Big G makes a surprise guest appearance with Suttle Thoughts. Big G, Steve Roy, LaKindra Shanea, Pretty Nikki and conga player Love can be seen in the back.

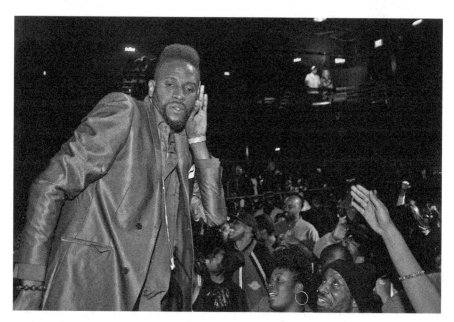

Big G listens for the audience's response while Backyard Band performs at Ibiza.

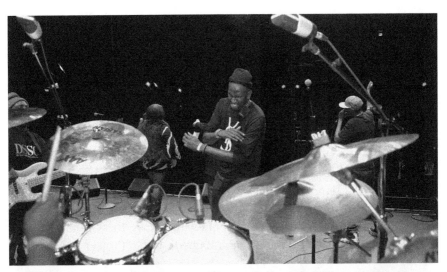

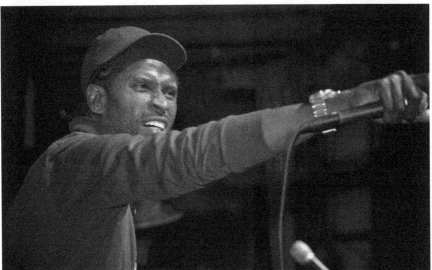

Top: Big G dances to the groove of longtime drummer Buggy while Backyard Band performs at the Fillmore. Vocalists Lissette TeTe and Weensy are seen facing the audience.

Bottom: Big G holds the microphone to the audience for their response at Chuck Brown's final birthday party at the 9:30 Club.

for his starring role in HBO's *The Wire*, where he played the character of Slim Charles. He has appeared in many shows and movies, including *Treme* and *Twelve Years a Slave*. Big G also hosts a radio show on a DC radio station under the name the Ghetto Prince.

GREG BOYER

While St. Mary's County native trombonist Greg Boyer spent eighteen years as a member of George Clinton's Parliament Funkadelic, for many years he has maintained a position as leader of Chuck Brown's horn section. Boyer is known not only for his perfect pitch and virtuosity on the trombone but also for his showmanship and on-stage funk antics. A classically trained musician, Boyer began playing music at an early age. When asked how many instruments he plays, he says, "All of them." Boyer has also been a member of Prince's NPG Band, as well as Maceo Parker's band.

Through all of this worldwide touring, Boyer has maintained a home in the DC go-go scene performing not only with Chuck Brown but also with Vybe Band, Backyard Band and Elijah Balbed's Jo-Go Project.

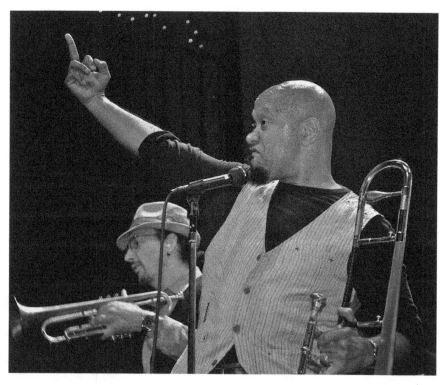

Having spent over eighteen years in George Clinton's Parliament Funkadelic, Greg Boyer brings funky energy to the stage.

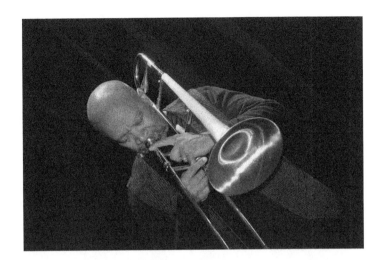

Top: While there is not an instrument that Greg Boyer cannot play, he is considered a virtuoso on his chosen axe, the trombone.

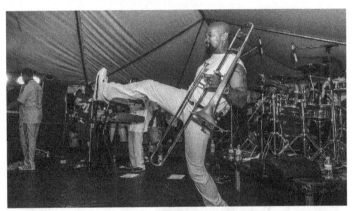

Middle: While leading the Chuck Brown horn section in its signature stage moves, Greg Boyer often breaks off into his own dance.

Bottom: While go-go is the music that never stops, it will stop and the performers will freeze in place and look at their watches when the lead talker says, "Check the clock."

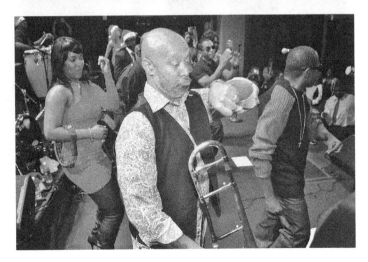

Boyer's Beltway Horns trio consists of Chuck Brown Band section mates Brad Clements, Elijah Balbed and himself, which not only is a sought-after studio trio but also often gets the call to perform when national touring acts come to DC. Performances with his band the Greg Boyer Peloton are known to sell out DC venues like Blues Alley and Bethesda Blues and Jazz. For more of Greg Boyer's story, read the foreword of this book.

GENNY JAM

New Jersey–born guitar player Genevieve "Genny Jam" Cruz moved to the DMV in high school and began taking guitar lessons. It wasn't long before she was playing in local bands. She soon found herself playing in go-go's first all-female band, Pleasure, in 1989.

At the time these photos were taken, Genny Jam was playing guitar in the all-female band Bela Dona. She has also toured worldwide with bands Salt-N-Pepa, Klymaxx, Hi-Five and Crystal Waters.

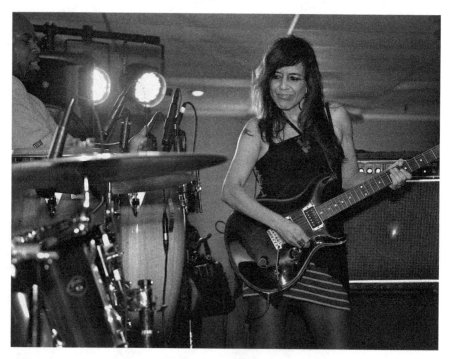

When James Brown created funk, he told all his band members to think of their instruments as drums. Genny Jam here plays her guitar percussively by "scratching" along with the conga and drums.

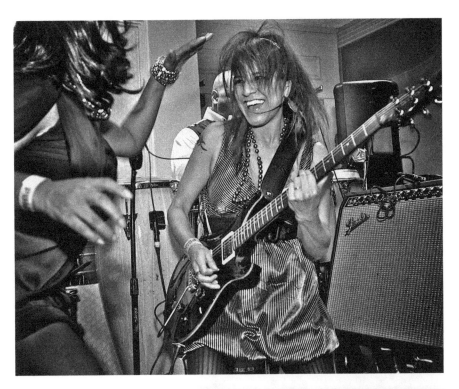

Above: Genny Jam feels the groove of her Bela Dona bandmates at this New Year's Eve performance.

Right: Genny Jam, dressed in funky fashion, gets her licks in at the 2010 Go-Go Hall of Fame Awards performance with Bela Dona.

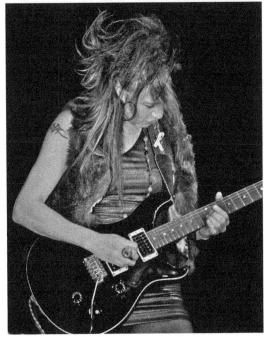

Genny Jam performs with
Bela Dona at the Fillmore.

KWICKFOOT

At one time, Kenny "Kwickfoot" Gross was known as "Mr. Call Me." He is
a drummer well known in go-go as someone who would drop what he was
doing at any moment, grab his cymbals, sticks and snare drum and arrive to
crank with any band that needed a drummer at the last minute, sometimes
playing several shows a night. But that's not all Kenny was known for. He
became known for his work on the bass drum, something critical in driving
the go-go beat—hence his nickname Kwickfoot, or simply Kwick. While
still being available for last-minute calls, Kwick settled in as the regular
drummer for Frank "Scooby" Marshall's band Lissen.

But with word getting out about his foot-driven rhythm, in 2008, he
got the call from Chuck Brown asking him to join his band, which Kwick
accepted. Keeping his position in Lissen, Kwick played with Chuck for
the last five years of Chuck's life and has since remained with the Chuck
Brown Band.

Kenny "Kwickfoot" Gross has also held down the regular drummer
position with Familiar Faces and Rare Essence, as well as touring nationally

Drummer Kwickfoot loves playing with his kids and will often bring one of his children to a day show. Here he is prior to the show on Chuck Brown Day at Chuck Brown Park with his son.

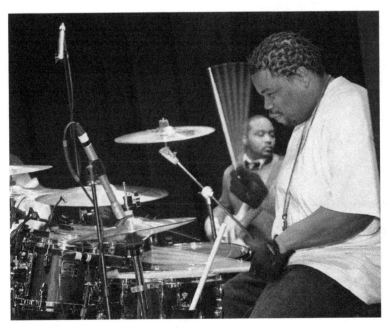

Kwickfoot cranking out the beat with the Chuck Brown Band at the Howard Theatre while bass player Ice carries the groove.

Kwickfoot, known for driving the beat on the bass drum, playing with Chuck Brown at Love nightclub. Notice how high up his leg is raised.

Kwickfoot performs with Chuck Brown at the Hampton Coliseum.

with rapper Wale. The thing Kwick loves most is playing with his kids. He will occasionally bring one of his children to a day show, and the child will entertain themselves on the side of the drummer's riser during the show.

STOMP

Though playing with bands such as Raw Image, Faycez U Know and others, Larry "Stomp" Atwater is best known for his role as the drummer in the Northeast Groovers (NEG). While at the time these photos were taken Northeast Groovers was not playing regular gigs, some members had assembled Da Mixx Band, which played regularly on the go-go circuit, with Stomp holding the beat on the kit.

Like Kenny "Kwickfoot" Gross, Larry is also known for his foot work on the bass drum, thus the nickname "Stomp." Stomp is also a recording producer for many artists in the DC area and operates a studio.

MIGHTY MOE

Conga player Maurice "Mighty Moe" Hagans has been a prominent player in go-go all of his life. The longtime conga player for Experience Unlimited, Moe traveled the world following their chart-topping hit "Da Butt." He also played in Maiesha and the Hiphuggers and was Chuck Brown's conga player; he and still plays in his honor in the Chuck Brown Band. Mighty Moe had a yearlong run as the only "Fella Dona" in the all-female band Bela Dona. While Moe delivers the crank around town at night, by day, he delivers the mail.

BLUE EYE

Drummer Darrell Arrington's nickname in go-go is "Blue Eye" or "Blue-Eyed Darrell" because one of his eyes is ocean blue. As one of go-go's longtime drummers, he is known for delivering the crank. At the time these pictures were taken, Darrell was the drummer for Rare Essence.

Top: Kwickfoot and Stomp backstage at La Fontaine Bleue.

Middle: Stomp cranks the beat while playing with an all-star go-go lineup at Marigolds.

Bottom: Stomp playing with Da Mixx Band at Marigolds.

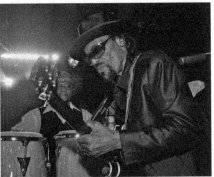

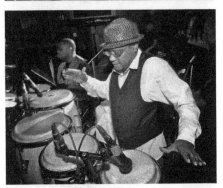

Top: Mighty Moe often uses sticks on the congas to perfect his tone and keep the beat. Moe's wife looks on.

Second: Mighty Moe and Kwickfoot carry out the percussive conversation familiar to go-go and also known simply as "cranking" while playing with Chuck Brown at Love Nightclub. Note the bucket on the stand under Mighty Moe's arm.

Third: Mighty Moe and Chuck Brown at Love Nightclub.

Bottom: The lightning speed of Mighty Moe's hands keeps the crank going while playing with the Chuck Brown Band.

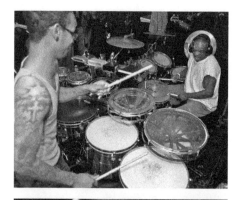

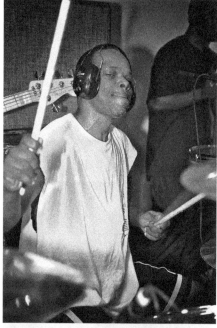

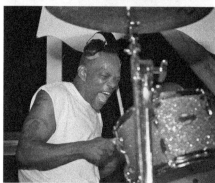

Top: Drummer Blue Eye cranks the kit, having a percussive discussion with Bee Jay on the roto toms as Rare Essence makes a New Year's Eve performance at La Fontaine Bleue. Bee Jay is Go-Go Mickey's son.

Middle: Blue Eye blazing his sticks as he performs at Marigolds with Rare Essence.

Bottom: Drummer Blue Eye plays passionately while performing at the all-star event Go-Go Under the Skies in Anacostia.

ELIJAH BALBAD

Like many horn players in go-go, Elijah Balbad began playing alto saxophone while in elementary school. He has said that growing up, he didn't know how much music meant to him until one day in the sixth grade when he lost his saxophone. When the horn was "miraculously" returned to him, he began taking his music seriously. In high school, Elijah took up jazz. DC jazz folks started to take notice of the Albert Einstein Jazz Band during Elijah's tenure there. While in high school, he got a job at the famed Dale Music Store, a store for serious musicians. At the store, Elijah met many of the gigging "cats" who played DC's lively jazz clubs.

While attending Howard University, Elijah began stepping out into the DC jazz clubs, sitting in with legends of that scene at U Street and Adams Morgan clubs Utopia, Café Nema, HR57, Bohemian Caverns and others that had open jam sessions. People took notice as Elijah became established in the DC jazz scene. After a year, Elijah left Howard to pursue a career as a full-time gigging DC musician.

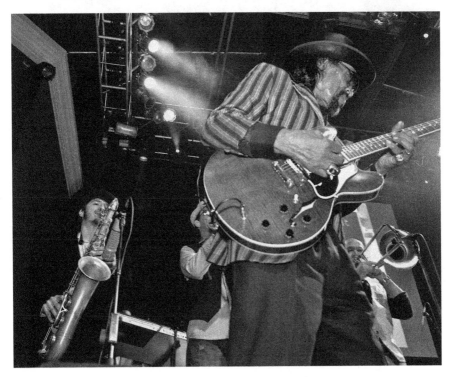

Elijah Balbad performs at his first gig with Chuck Brown at the 9:30 Club.

Elijah Balbad and horn section mate Brad Clements during a performance with the Chuck Brown Band.

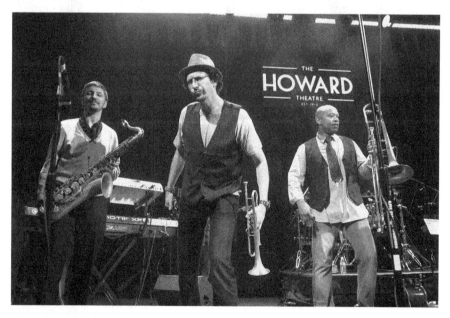

Chuck Brown's horn section, now known as the Beltway Horns, up to some onstage antics. Elijah Balbad, Brad Clements and Greg Boyer at the Howard Theatre.

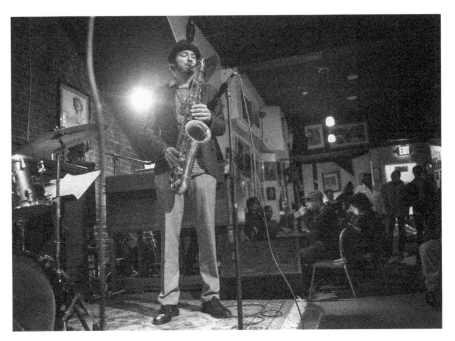

Elijah Balbad performing with one of his jazz ensembles at a sold-out Alice's Jazz and Cultural Society. DC music legend DeAndrey Howard, manager of the club, stands in the far back by the door.

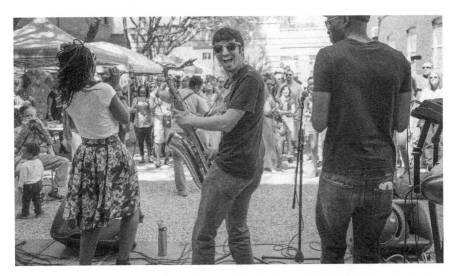

Elijah Balbad leading his jazz/go-go band, the JoGo Project, at DC's Funk Parade. Dr. Jocelyn Imani sings into the microphone on the left; an unknown trumpeter plays on the right.

In the fall of 2011, Elijah got the call from Chuck, who asked him to play alto sax in his band after longtime sax player Bryan Mills left to start his own band, Secret Society. Elijah played at what became the last of Chuck Brown's performances and then stayed on with the Chuck Brown Band.

While an artist in residence at Strathmore Music and Arts Center in 2014, Elijah combined both jazz and go-go into a band he called the JoGo Project, which regularly gigs around DC, often featuring the top names of go-go.

His 2015 studio release, *Lessons from the Streets*, received critical acclaim and solidified Elijah's presence in the DC jazz scene. Performances of Elijah's jazz ensembles regularly sell out the jazz clubs in DC.

After working with the Chuck Brown horn section of Greg Boyer and Brad Clements, they brought Elijah and his talent to their trio, known as the Beltway Horns. This trio is one of the most sought-after horn sections, not only for performance work, but for studio session work too.

KEKE

Singer Kenecia "KeKe" Taylor began her go-go career while still in high school with a band called Mad Collision, a group of young musicians that included one of Go-Go Mickey's sons. People took notice, and soon she was offered a spot on the mic with the Critical Condition Band, more commonly known as CCB.

KeKe and White Boy of Rare Essence singing together at a New Year's Eve show at La Fontaine Bleue.

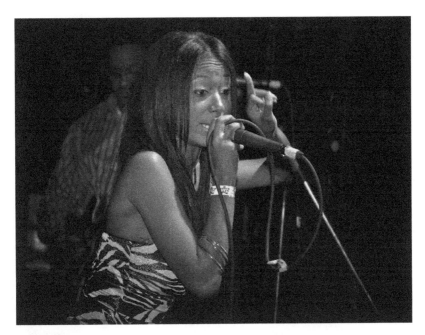

KeKe of Rare Essence at the Chocolate City Reunion Show at Fur Night Club.

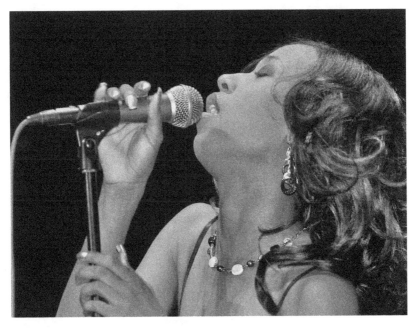

KeKe of Rare Essence at the 2010 Go-Go Hall of Fame Awards.

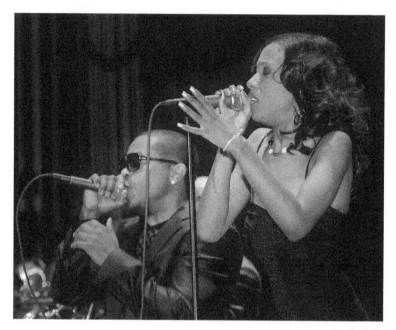

KeKe and Shorty Corleone of Rare Essence performing at the 2010 Go-Go Hall of Fame Awards held at the Lincoln Theatre on U S treet.

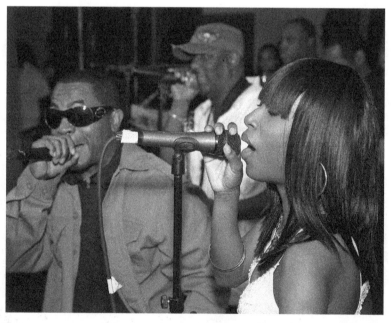

Rare Essence at Tradewinds. KeKe, Shorty Corleone and D. Floyd are on the microphones, with Roy Battle in the background.

While she was with CCB, the band recorded and released two albums: the self-titled *Critical Condition Band*, followed by *Diversity*. Two original singles from these albums featuring KeKe, "I'm Classy" and "My Phatty," received airplay on DC stations and in other markets.

KeKe took a few years off from singing and performing and then got a call from Andre "White Boy" Johnson to audition for Rare Essence, where she gracefully filled the shoes left by Ms. Kim.

ICE

Karlston "Ice" Ross was Chuck Brown's bass player at the time that these photos were taken. Like many artists in go-go, musically Ice came from a strong church background. He got the call from Chuck in 2008. Ice toured the country as part of Raheem DeVaughn's band. Unfortunately, Ice passed away from a sudden illness in 2016. He was thirty-three years old.

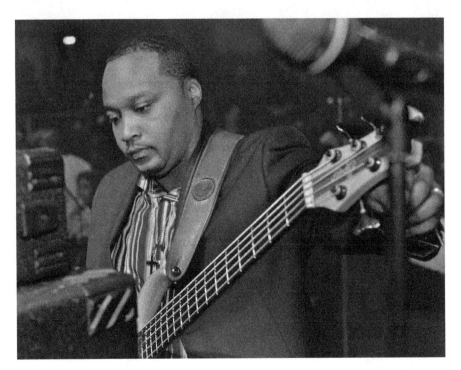

Karlston "Ice" Ross tunes his bass prior to a show with Chuck Brown at the nightclub Ibiza.

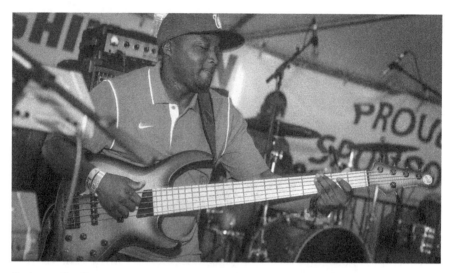

Karlston "Ice" Ross performs with the Chuck Brown Band at DC's Barbeque Battle.

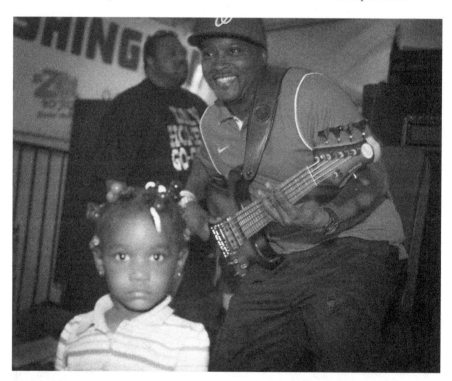

Karlston "Ice" Ross looks side stage to his wife and kids while performing with the Chuck Brown Band at DC's Barbeque Battle. His daughter appears out of the depth of field, and Chuck's longtime stagehand Christopher Lee appears in the back wearing one of the T-shirts he custom-made for each show.

PEEKASO

Although not a musician, Demont "Peekaso" Pinder is truly the artist of go-go. A self-styled painter, Peekaso can often be seen onstage along the bands with an easel, canvas and brushes, carefully painting while the bands crank and the audience grooves. Peekaso could often be seen sharing the stage with Backyard Band, Black Alley and Chuck Brown. But Peekaso's work onstage is not just limited to go-go. Peekaso and his brushes have toured the country with Wale, Raheem Devaughn and Jay-Z.

When the newly renovated Howard Theatre opened in the spring of 2012, Peekaso was commissioned to paint the hallways and stairways that lead to the downstairs dressing room with portraits of the artists who performed there in the present as well as the past.

Musicians are not the only subject of Peekaso portraits; many of his paintings and murals show the struggle of those living in DC. He will pause his schedule all too often to paint portraits of the child victims of DC's gun violence.

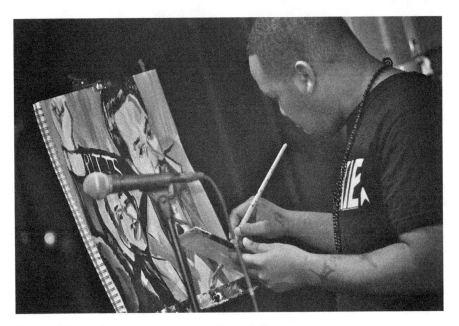

Demont "Peekaso" painting onstage at the Howard Theatre.

THE FANS

In the foreword of this book, Greg Boyer states, "There's something in the way that a DMV audience throws right back at you what you throw on them. It's always the feeling that not all of the band members are on the stage with you; they are also in front of you. They're participants of the music being played, not just listeners." No one can come to any understanding about go-go without an understanding that the fans and the energy that they bring to the band, the equal exchange of that energy, is the largest part of go-go. Seeing a go-go band play to an empty room or in a sit-down venue, one will never feel the true essence of what go-go truly is.

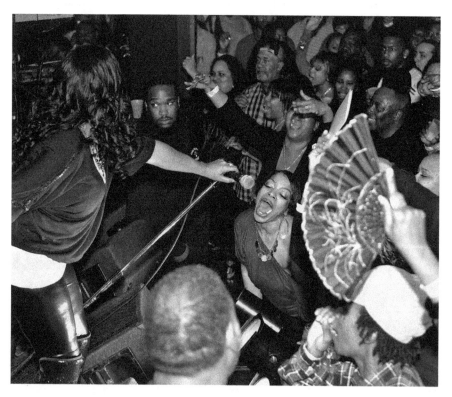

Bela Dona's Karis Hill holds a microphone to a fan as the audience sings along.

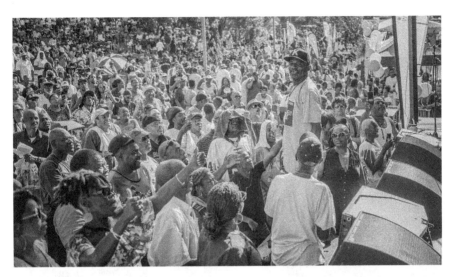

If you grew up in Southeast DC, you know legendary street rapper Thomas "Kokamoe" Goode, who rapped on city buses. Here, fans pay homage as Kokamoe makes an appearance at one of the Chuck Brown Day celebrations at Chuck Brown Park.

Often called the "Mayor of Go-Go," Troy "Too Smooth" is one of the top fans of go-go. If Too Smooth is in the building, then you are where the party's at.

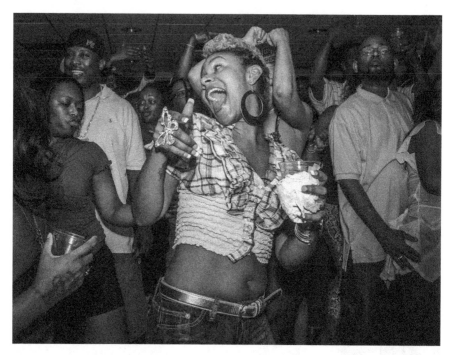

Front-row fans at a Rare Essence show at Marigolds.

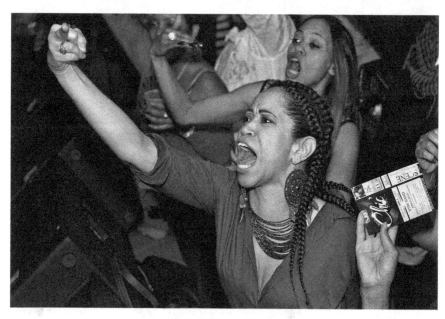

DC angst is properly expressed at a go-go. Note the flyer in this fan's hand about upcoming shows.

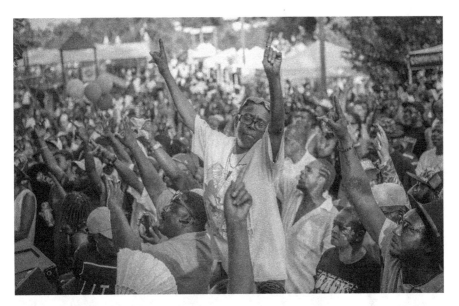

Fans at a Chuck Brown Day celebration.

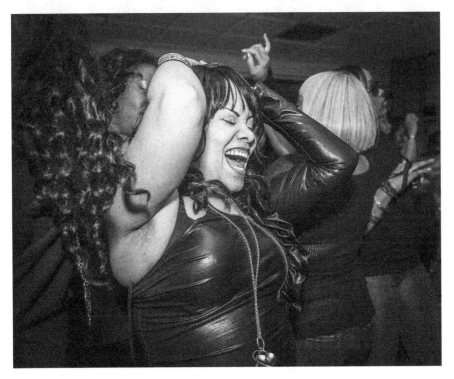

A go-go fan at a Rare Essence show at Marigolds.

The energy of go-go brings this man to his feet.

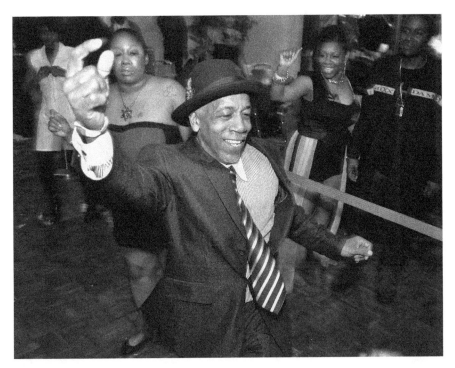

Go-go, now in its fifth generation, attracts both young and old.

A fan feels the go-go groove at an outdoor Junkyard Band show.

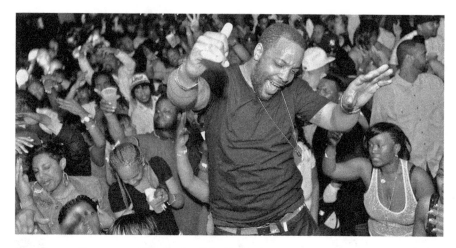

Rare Essence fans at one of the Battle of the Bands shows.

THE BUSINESS

arly on, as go-go moved from the streets, neighborhood get-togethers, block parties and social events to the clubs of DC, many of the established local bands like Trouble Funk, Rare Essence, Reds and the Boys, the Young Senators and Experience Unlimited began to adapt the go-go sound and style. A business model began to develop within go-go that was key in the growth of its economic vitality. It's why go-go is often described as party music and why many keen observers in the go-go community often say, "Go-go is not in the music business. Go-go is in the party business."

By the mid-1980s, the time when go-go began hitting its stride, the crack epidemic and the violence associated with it began infecting the people from the neighborhoods and parts of the city where go-go music had originated. The streets of DC had turned horribly violent, and DC became the Murder Capital of the World. Local officials and news media alike began unjustifiably associating go-go music with the horrible violence that came with the crack epidemic. The DC government started padlocking the clubs where go-go bands performed. As a result, DC clubs that had previously welcomed the go-go bands and their ever-growing followers ceased booking go-go bands.

Go-go began to look for other places to perform that were not in the spotlight. As those in the go-go business were lacking capital to build their own clubs, go-go started being played in venues not specifically built for live music performances, such as banquet halls, VFW posts, hotel ballrooms, bars or restaurants with dance floors—any space that was large enough to set up a band, pack in large crowds, set up a bar and hold a party for a night. Many

of these makeshift music venues began to hold these go-go performances every week, booking individual bands on certain nights regularly. These venues became known as the "spots." Bands began playing spots on specific nights throughout the city and suburbs. A go-go fan knows which bands are at which spots on any given day of the week. At the time that these pictures were taken, everyone in go-go knew that Rare Essences' Friday night spot was at Tradewinds, a large-capacity Asian restaurant converted to a makeshift music venue that also hosted Backyard Band on Thursday nights. Backyard Band's Friday spot was at the Legend, an old postwar nightclub built from a World War II surplus quonset hut that had operated as a classy blue-collar supper club for many years, known as the Quonset Hut, before becoming the Legend. The venue hosted many musical acts that went on to become huge national acts, as well as many well-known burlesque dancers. Junkyard Band's Friday night spot was at Club Elite, a former Tex-Mex restaurant turned go-go spot. On Thursday nights, La Fontaine Bleue, a swanky catering house in Glen Burnie, Maryland, had a regular lineup of DaMixx Band, Bela Dona and Suttle Thoughts that drew 1,600 people. Monday Night Football nights were out at the newly built but failing shopping center Capital Boulevard, where the Capital Centre once stood. People could park their cars and walk back and forth between several go-gos at the challenged restaurants and wing shops that would soon go out of business as the large shopping center was redeveloped into a medical center. Black Alley had a Thursday night spot at Club 7 on Seventh Street in the city, and their Friday night spot was at the Breakfast Club, a large upstairs room at a famed DC jazz club, the now-shuttered Bohemian Caverns. Suttle Thoughts' Friday night spot was late night at uptown jazz club Takoma Station.

This made go-go nimble. If any one of these spots went out of business or took heat for having go-go at their business or restaurant, another spot would be found, and the beat kept going. For the musicians, these regular spots allowed steady work and steady paycheck. Go-go could be found in the DC area just about every night of the week, and if you were into go-go, you simply knew the spots. If you didn't know go-go, you knew nothing of this. At this writing, all of these spots, with the exception of Takoma Station, are no longer in existence, but in the time since, other spots have taken their places.

Key to this business model is the role that promoters and managers play in the business of go-go. Go-go bands are manager-based bands. From the beginning, a go-go band is a commercial enterprise with the manager as the owner. Often, a prominent go-go star may have a leadership role and

ownership position in the band. Managers start the bands, pay the musicians and cover costs of rehearsal space and any other overhead. In turn, the musicians work for the managers. The managers develop relationships with the promoters; handle all the bookings and negotiations and so on. They pay the musicians and keep a profit for themselves.

Party promoters, or simply promoters, in go-go are the people who make everything happen. They rent the space, book the bands, hire the backline providers and crew, bring in the backdrop photographers, stock the bar, hire DJs and more. Promoters front the deposits to bands, venues and sound crews. They get the liquor licenses; often, they are temporary licenses specific to an event. Promoters make everything happen to ensure that everything goes off as planned on the night of the party.

Promoters then promote. They are responsible for getting the word out to the masses—but not the whole masses. It was seldom that ads were placed in the *Washington Post*'s popular weekly arts and entertainment section, known as the "Weekend Section," or the city's edgy alternative weekly the *Washington City Paper*, where all of the club shows were advertised. Go-go promoters used a very specific and effective targeted approach to their advertising. Promoting go-gos early on consisted primarily of handing out flyers and posting street signs in specific neighborhoods. When one leaves a go-go, there is a gauntlet of people placing flyers of all sizes into their hands. These are well-designed flyers with flashy graphics, pictures of go-go stars and pretty ladies. After people get through the gauntlet and walk through the parking lot, they often find dozens of flyers adorning their cars and all of the other cars in the lot. DayGlo-colored posters with big, bold, fat typestyles from the famous Globe Poster Company in nearby Baltimore were attached to phone poles, streetlights and vacant shop windows around the city. These signs were not placed on K Street or in the wealthy white area of upper Northwest but on streets like North Capital Street, H Street NE and Benning Road SE that ran through neighborhoods like Congress Heights, Riggs Park, River Terrace and Barry Farms. Globe Poster Company closed its doors in late 2011 as changes came to the printing industry and social media gave way to a new communication technology for the music industry. In later days, social media become the primary medium for getting the word out to folks.

Musician, producer and playwright Kato Hammond started a website called Take Me Out to the Go-Go (www.tmottgogo.com) in 1996. It provided the latest go-go news, photos and announcements, but the most popular part of TMOTTGOGO was its chat room. Go-go musicians and fans were known to spend hours there each day discussing the goings-on of go-go. For

lively discussion about current band lineups, show reviews and spilling the gossip (there is lots of gossip in go-go), Hammond's site became the one-stop shop, providing everything anyone needed to find out about go-go. Soon it became the place for promoters to advertise their shows. And advertise they did! Mr. Hammond himself was able to make a living off this site until social media became popular at the end of the aught years.

As social media began to grow, many Facebook groups specifically about the genre gained popularity. Go-go bands as well as musicians set up their own fan pages. While fans were able to chat about their go-go experiences, bands and promoters were able to promote their shows directly to go-go fans.

The sound of the city can be heard as one passes through, not only from the bucket drummers on the corners, but the beat and performances can also be heard from soundboard recordings from house and apartment windows, car speakers, cookouts and Bluetooth speakers. While back in the day go-go bands released professionally produced studio albums, today most recorded go-go consists of soundboard recordings of live shows.

Compact discs of live performances were readily available for sale at shows, barbershops and several stores dedicated specifically to the sale of these live shows. Bands made it a point to release recordings of their live shows for sale every several months. Often, band members were paid their share of the proceeds from these recordings not in cash but in product that they would then sell for themselves. With technology making replication of CDs as well as the free distribution of music in digital formats, the last of these stand-alone stores catering to go-go closed up shop in 2017.

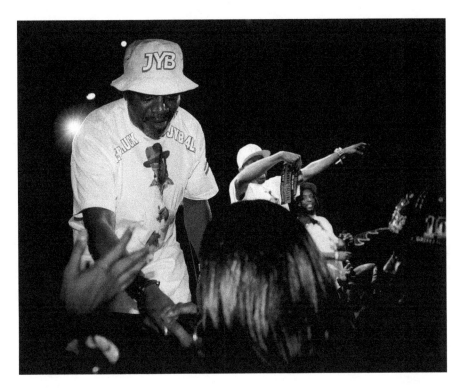

Junkyard Band leader and founder "Bugs" holds a microphone to a fan at the Howard Theatre.

While trombone player Greg Boyer has toured the country with Parliament Funkadelic, Prince and Maceo Parker, he always comes home to play with Chuck.

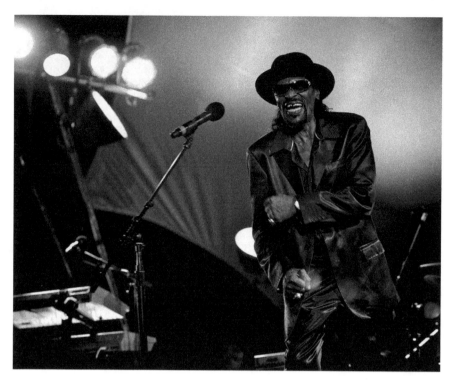

Chuck Brown was a happy man the night he was honored by the National Symphony Orchestra. Here, Chuck hits the last beat of his song "Run Joe," which was played as an orchestral arrangement.

Familiar Faces' Quisey sings to a fan while performing at the Eclipse Nightclub.

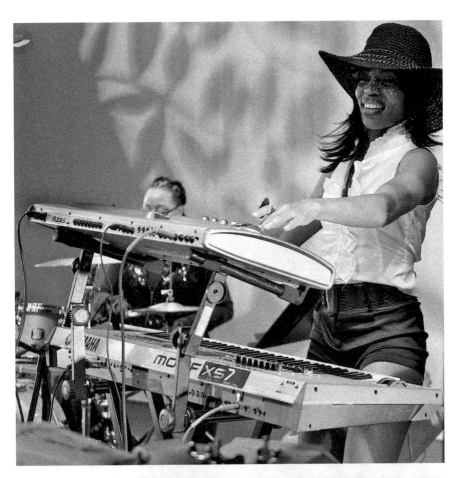

Above: Bela Dona
keyboard player
Claudia "Kool Keys"
Rogers performing at
the Kennedy Center.

Right: Chuck's
daughter KK strikes
her own fashion while
performing at Love
Nightclub.

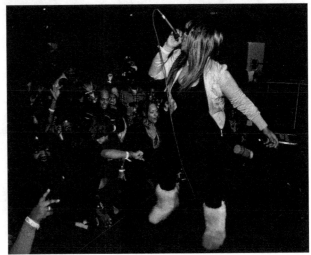

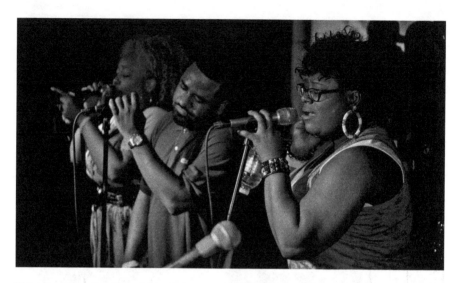

Vybe Band frontline. *Left to right*: MzLaydee, Derrick Holmes and Kimise Lee.

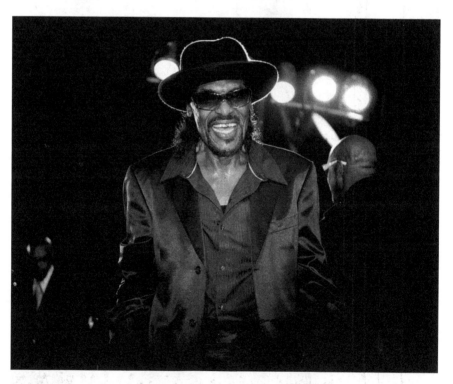

Chuck Brown leaving the stage after being honored by the National Symphony Orchestra in front of fifty thousand people on the West Lawn of the U.S. Capitol.

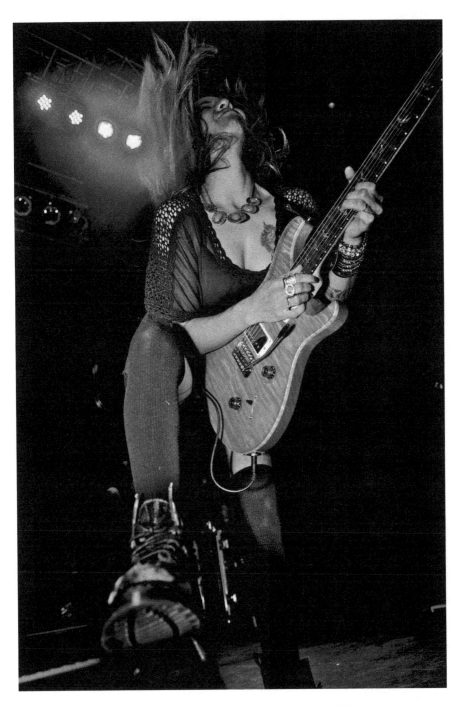

Bela Dona's Genny Jam brings her rock-and-roll/death metal guitar influence to go-go.

Chuck's longtime trumpet player Brad Clements playing his trumpet on U Street.

DJ Dirty Rico spins between Rare Essence's sets at Fur Nightclub.

Left: Globe Posters' work once lined the street corners and empty storefront windows promoting go-go shows.

Below: Black Alley performs at the Kennedy Center's Millennium Stage

Rare Essence drummer "Blue Eye."

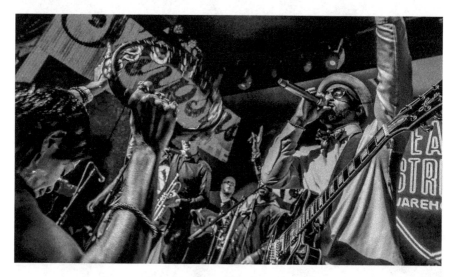

While the Chuck Brown Band plays, fans join in with tambourines.

Party Crashers, a popular comedy duo, often makes appearances at go-gos and often could be seen dancing in front of Central Communications.

"Sweet Cherie" on keyboard with "Mighty Moe" cranking the go-go beat.

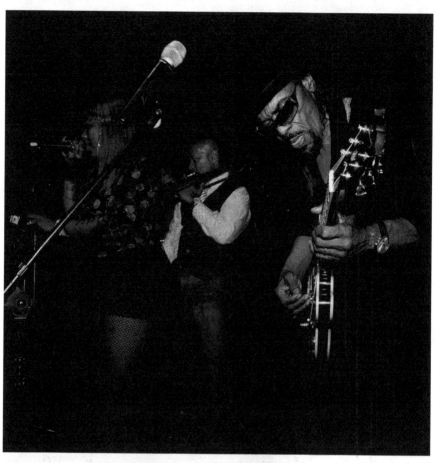

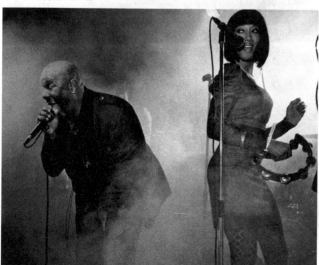

Above: KK, Greg Boyer and Chuck Brown at one of his final performances.

Left: Familiar Face's D. Floyd and Ms. Kim performing at Love Nightclub.

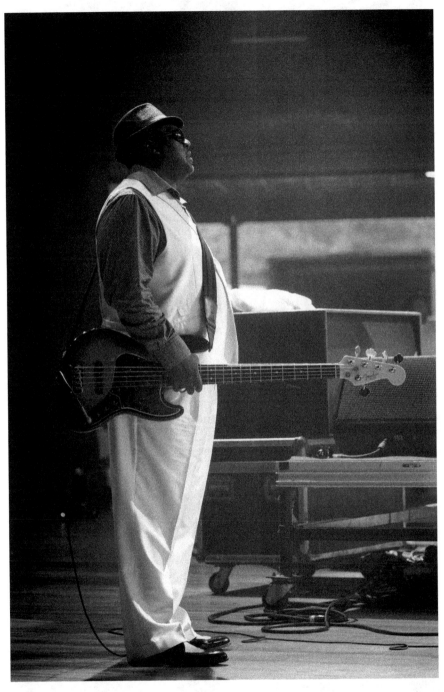

Trouble Funk's Big Tony waits backstage moments before performing a Chuck Brown tribute show at Meriwether Post Pavilion.

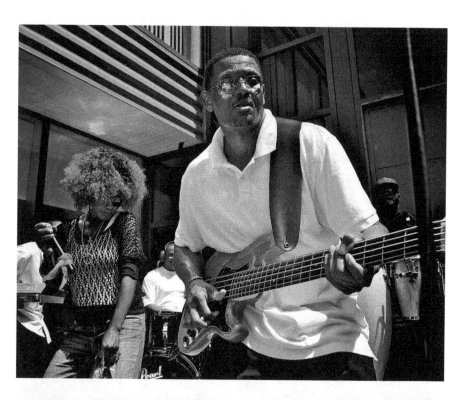

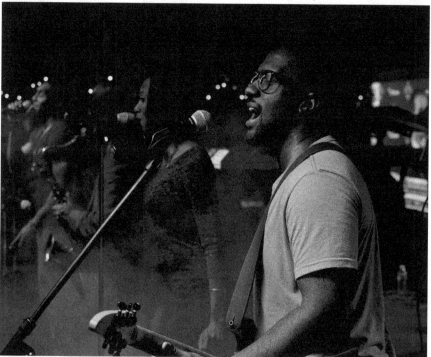

Opposite, top: Halima Peru and "Doc" Hughes of Faycez U Know performing at the Anacostia Community Museum.

Opposite, bottom: Familiar Faces performs at La Fontaine Bleue.

Above: Founding member of Rare Essence Andre "White Boy" Johnson.

Rare Essence performing at Marigolds Nightclub.

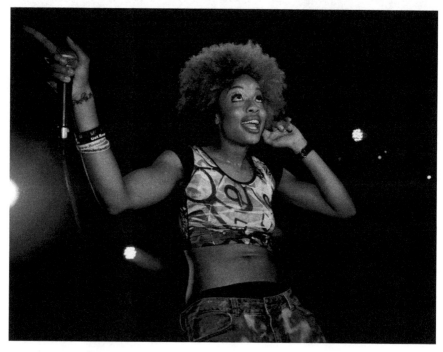

Ressa Renee, an R&B/soul singer from DC who incorporates go-go into her music, listens to the response from her audience.

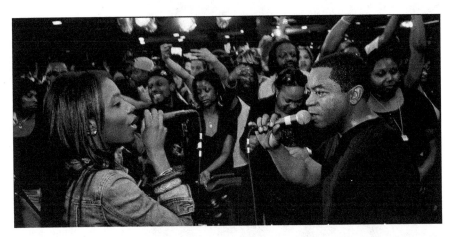

Rare Essence's KeKe and Shorty performing at Tradewinds floor level and face to face with the audience.

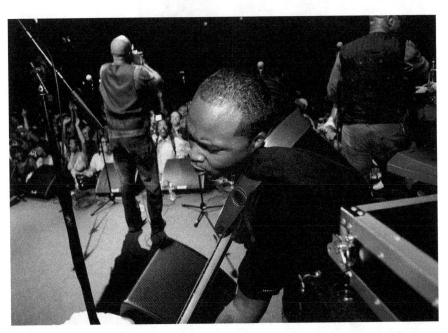

Karlston "Ice" Ross leans into the groove of his bass lines as D. Floyd performs his version of Biggie Smalls's "Warning" at Chuck Brown's final birthday party at the 9:30 Club. RIP, Ice!

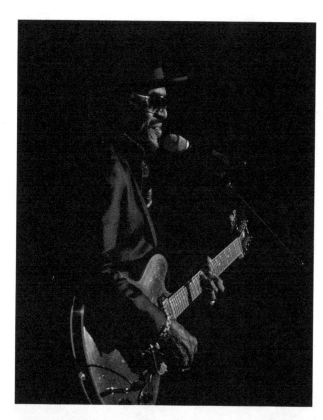

Left: Chuck Brown performs at Hampton Coliseum.

Below: Call and response is a major element in go-go. Chuck Brown holds the microphone to the audience for their response to his call.

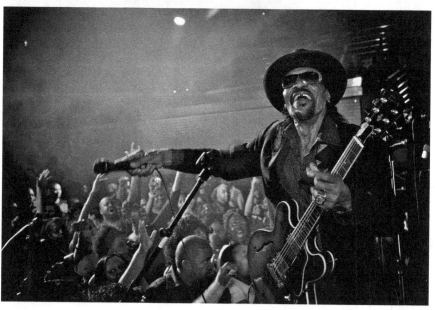

THE BANDS

D uring the time these images were captured, the following bands were the prominent standouts and were playing a circuit of spots around town. Go-go bands frequently change members, and stars will often do guest appearances with another band. These are the member lineups of go-go bands during the period that these images were captured. Most of these bands have changed their lineups since.

CHUCK BROWN'S BAND

Much has already been said in this book about Chuck Brown. See chapters 1 and 4 for more on Chuck.

At the time these photos were captured, Chuck Brown's band lineup consisted of Chuck's daughter "KK," rapper; "Sweet Cherie," keys and vocals; Bryan Mills, sax and keyboards; Karlston "Ice" Ross, bass (RIP); Kenny "Kwickfoot" Gross, drums; "Mighty Moe" Haggens, congas; Donnell "D. Floyd," vocals; Brad Clements, Greg Boyer and Elijah Balbed, horns; and Marcus Young, keys and vocals.

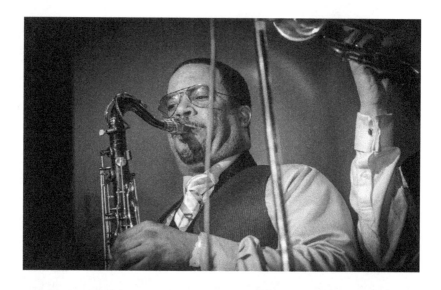

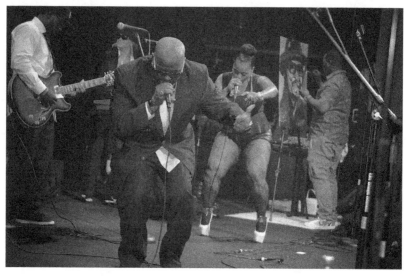

This page, top: Chuck's longtime sax and keyboard player Bryan Mills.

This page, bottom: D. Floyd and KK dance onstage while Demont Peekaso paints.

Opposite, top: Following Chuck's passing, his son Wiley joined the Chuck Brown Band. *Left to right*: KK, Wiley Brown, Greg Boyer, D. Floyd and Scooby.

Opposite, middle: Chuck's family always made him proud. Here, Chuck performs with his daughter KK.

Opposite, bottom: Chuck Brown and his band at Baltimore's Funk Festival. *Left to right*: Bryan Mills, Brad Clements, Greg Boyer, Ice, KK and Chuck

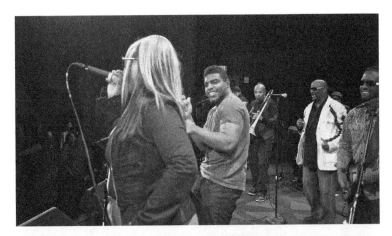

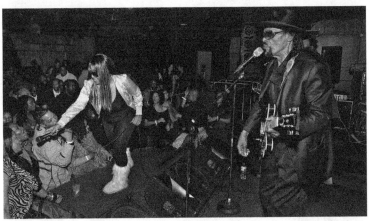

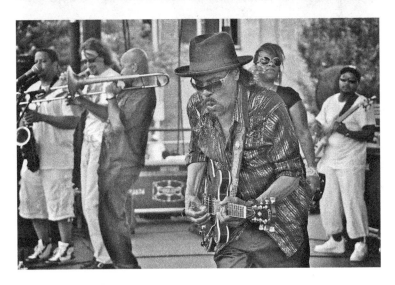

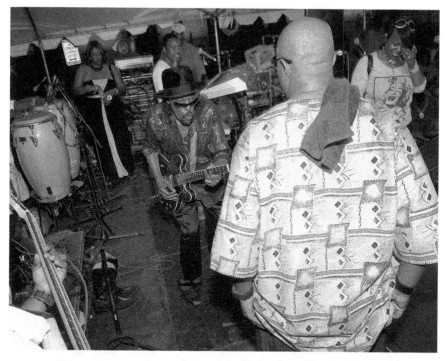

Chuck Brown surprised not only his audience but everyone onstage when, shoeless, he chose to duck walk across the stage Chuck Berry style at the annual Barbeque Battle that Chuck had headlined for many years. Both of Chuck's daughters, Cookie and KK, along with keyboard player Marcus Young, can be seen with different looks on their faces as Chuck duck walks toward a stunned D. Floyd.

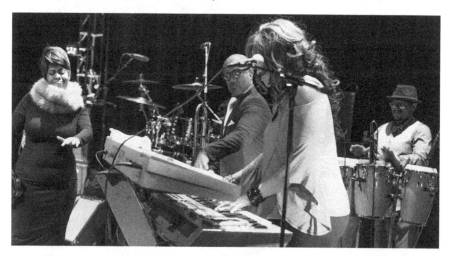

Chuck Brown Band members KK and Greg Boyer mock Sweet Cherie during one of her solos while Mighty Moe holds back a laugh but never misses a beat on the congas.

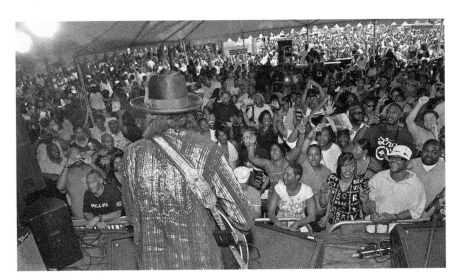

Chuck Brown headlined DC's annual Barbeque Battle for many years, and the crowds always showed out.

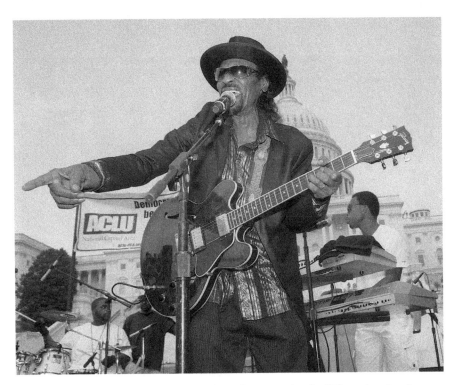

Chuck Brown performs in 105-degree heat at a demonstration for DC statehood at the United States Capitol.

RARE ESSENCE

Undoubtedly one of the standout bands when it comes to go-go is Rare Essence. Originally called the Young Dynamos, Rare Essence is one of the early bands to adopt the go-go sound in the late '70s. While go-go was invented by Chuck Brown, it was perfected by Rare Essence.

Throughout Rare Essence's forty-five-year history, they had a string of successful original hits, including "Body Snatchers," "Work the Walls," "Body Moves," "Lock It" and Ms. Kim's go-go rendition of Ashley Simpson's "Pieces of Me."

Rare Essence at its peak was one of the hardest-working bands in go-go, often performing seven nights a week, and it wasn't rare for them to do several shows in one day. Their lineup changed many times over their long history, and many go-go musicians have been members of Rare Essence. Go-go media mogul Kato Hammond has said over and over again, "Rare Essence is not so much a band but an organization that employs musicians."

In 2017, Snoop Dogg posted a video of himself riding in a car and blazing to Rare Essence's old-school tune "Hey Buddy Buddy." In response,

For the final set of Rare Essences' shows at Tradewinds, the band invites the ladies onstage with them, and the band and fans become one. White Boy performs while a fan dances back to back with him.

Rare Essence performs at the 2010 Go-Go Hall of Fame Awards at the Lincoln Theatre. *Left to right*: D. Floyd, Shorty Coreleon and KeKe.

Rare Essence's frontline. Left to right: Kila Cal Da Animal, Shorty and KeKe.

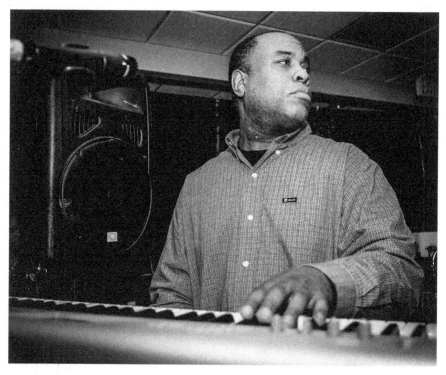

Longtime Rare Essence band member Roy Battle, who plays keys and trombone. He also wrote, produced and arranged many songs for Rare Essence and other bands.

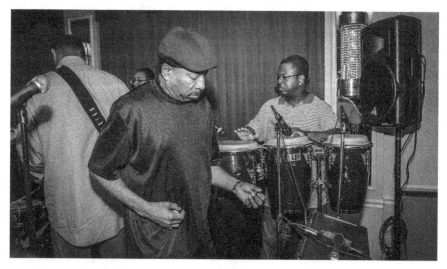

Rare Essence's Jas Funk and Go-Go Mickey. White Boy has his back turned, and Go-Go Mickey's son BeeJay can be seen in the rear.

the band wrote a song for Snoop and sent it to him. A year later, when Snoop Dogg was in DC for the DC opening of the stage play about his life, *Redemption of a Dogg*, he got together with the band for a late-night studio session and laid down the track for what would become the single "Hit the Floor," which Rare Essence released via YouTube in 2020.

At the time these images were captured, the lineup for Rare Essence consisted mostly of longtime members Andre "White Boy" Johnson, James "Jas Funk" Thomas, Leroy "Roy" Battle, Charles Quentin "Shorty Dud" Ivy, Byron "B.J." Jackson, Eric "BoJack" Butler, Go-Go Mickey, "Blue Eye" Derek "DP" Paige and Keke. During this time, DC rapper Calvin "Killa Cal Da Animal" Henry joined the band.

BELA DONA

While there have been several all-female bands in go-go's history, during the time these images were captured, Bela Dona was not only the only all-female go-go band but also one of the most successful bands on the go-

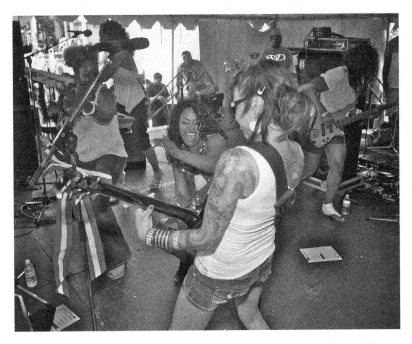

Bela Dona performs at the DC Barbeque Battle. *Left to right:* Sweet Cherie, Bléz, Tempest Storm, Wendy Rai and Genny Jam.

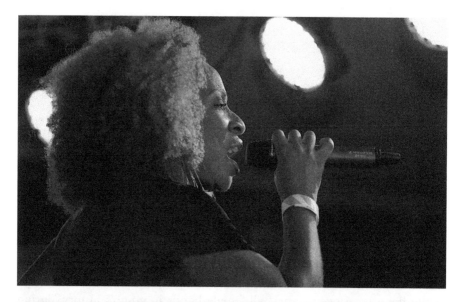

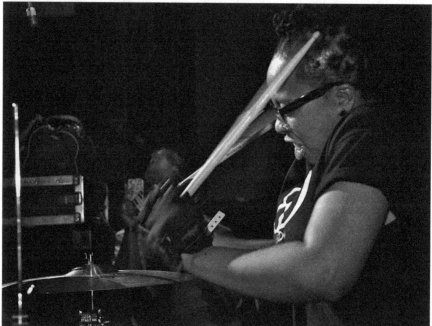

Top: Bela Dona singer Bléz.

Bottom: Bela Dona's drummer Shannon Browne.

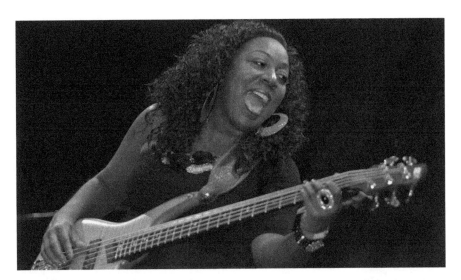

Bela Dona bass player Tempest "Storm" Thomas.

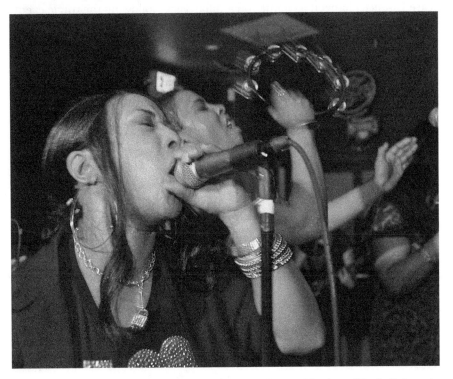

Bela Dona's lead talker Karis Hill shouts out to the audience while singer Wendy Rai cranks her tambourine.

go circuit. Bela Dona filled La Fontaine Bleue as part of Martin "Made in the City" Cooper's Thursday night lineup. Bela Dona often had five-plus performances each week. They not only played the DC circuit of go-go spots but also toured the country as the house band for DJ Spinderella's Black Girls Rock tour, performing with the country's top female R&B vocalists.

At the time these images were created, the lineup for Bela Dona consisted of Bela Dona's founder, Cherie "Sweet Cherie" Mitchell-Agurs; Claudia "Kool Keys" Rogers, keys; Karis Hill, lead talker; Genevieve "Jenny Jam" Cruz, guitar; Shannon Browne, drums; "Tempest Storm" Thomas, bass; and Wendy Rai and Rhonda "Bléz" Coe.

FAMILIAR FACES

Originally called 911, Donnell Floyd's band that he formed upon leaving Rare Essence changed its name to Familiar Faces following the tragic events of September 11, 2001. The band played the go-go circuit for most of the 2000s and then took a break in the final years of the decade; many members moved on to other bands.

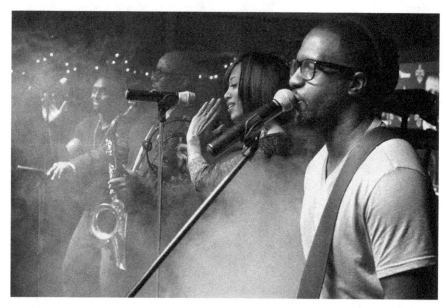

Familiar Faces frontline. *Left to right*: Quisey, D. Floyd, Ms. Kim and Scooby.

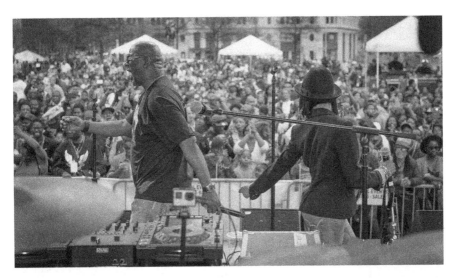

D. Floyd and Ms. Kim perform in front of thousands at DC's Annual Emancipation Day celebration at DC's Freedom Plaza.

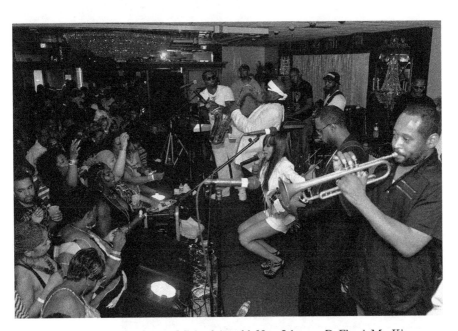

Familiar Faces. *Left to right*: Quisey, Michael Arnold, Nate Johnson, D. Floyd, Ms. Kim, Scooby and DP. Also in the background is stagehand and sometimes cowbell player Packey and side stage to at the back of this photo is Patrick

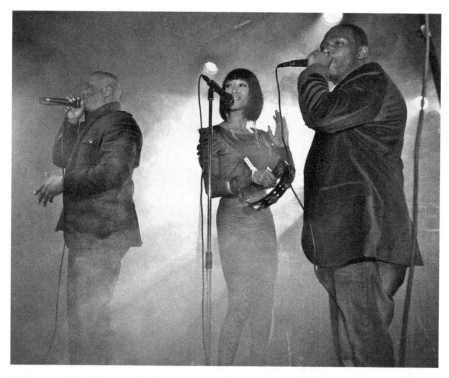

D. Floyd and Ms. Kim are joined on the frontline by rapper and horn player Jasen "O" Holland.

Familiar Faces' Jasen "O" Holland on his trumpet.

Familiar Faces' Quisey sings.

After performing for a few months with Rare Essence again and joining the Chuck Brown Band following the sudden death of L'il Benny, Donnell Floyd rolled out an entirely new lineup for the band in late 2011. It featured Donnell "D. Floyd" Floyd, lead talker, bandleader and saxophone; Byron "B.J." Jackson and Michael Arnold, keys; Jeffrey "Jammin' Jeff" Warren, drums; Milton "Go-Go Mickey" Freeman, congas; Eric "Bojack" Butler, timbales and cowbell; Derick "DP" Paige, trumpet; Sean Geason, bass; Frank "Scooby" Marshall, lead microphone and guitar; and Marquis "Quisey" Melvin and Ms. Kim, frontline singers.

The band had regular nightly spots at Takoma Station, La Fontaine Bleue, Marigolds, Takoma Station, Society Lounge and Fast Eddie's. The band often played eight to ten shows a week.

SUTTLE THOUGHTS

Go-go band Suttle Thoughts held down the longest residence in go-go with its ten-year Friday-night run at Takoma Station. Suttle Thoughts also had the longest run as the headlining band at the very popular La Fontaine Bleue.

At the time these images were created, Suttle Thoughts' frontline consisted of Steve Roy, Nikki "Pretty Nikki" Brown, Chi-Ali and LaKindra Shanea; Daryl Estep and Julian Lane on keys; Blue Wynn and Don DeMarco Myles on horns; Sean Geason on bass; and James "Darkness" Ellis on drums.

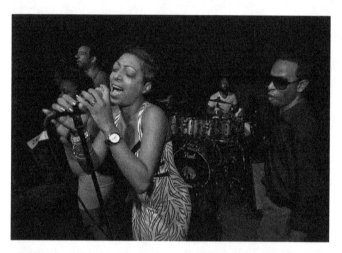

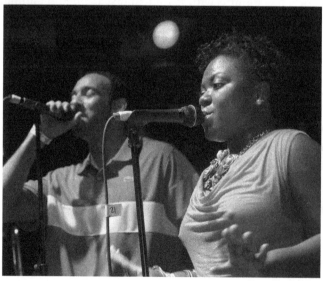

Top: Suttle Thoughts. *Left to right*: Steve Roy, Lakindra Shanea, Pritty Nikki, Darkness on drums and Chi Ali.

Bottom: Suttle Thoughts' Lakindra Shea and Steve Roy.

Suttle Thoughts. *Left to right*: Pretty Nikki, Chi Ali and Don DeMarco Myles.

BACKYARD BAND

The Backyard Band, like many go-go bands, got its start playing on the streets of DC, but unlike most go-go bands, Backyard Band has kept most of its core members intact for over thirty years. Backyard's own unique go-go sound combines rock infusions, bounce beat and Anwan "Big G." Glover's own distinctive rapping style as the lead talker, with Buggy and Sauce holding down the beat.

Over the years, Backyard Band (often called BYB or just Back) has had a string of local hits, "Pretty Girl" and "Skillet" being two of the most popular. In 2016, Backyard's version of Adele's "Hello" gained attention throughout DC with radio play and critical acclaim.

Backyard Band maintains a steady club presence in DC. When these images were created, they filled the clubs, with their regular spots being the Legend, Tradewinds, Capitelle and The Scene. Their thirtieth anniversary at the Howard Theatre drew an epic crowd.

BYB consists of Anwan "Big G" Glover, lead talker; Leroy "Weensey" Brandon, vocals; Earl Vincent, vocals; Lisette TeTe, vocals; Carlos "Los" Chavels, rapper; Keith "Sauce" Robinson, percussion; Paul "Buggy" Edwards, percussion; Bobby "Bob" Terry, lead guitar; Nathaniel "Nate" Field, bass guitar; Eric "EB" Britt, keyboard; Michael "Mike" Dunklin, keyboard; and Marcus Johnson, keyboard.

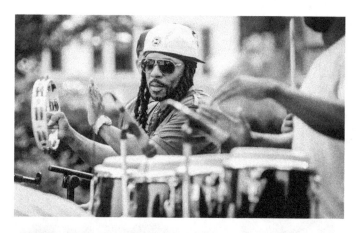

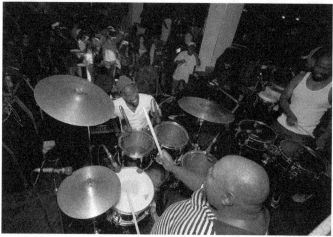

Top: Backyard Band rapper Los on tambourine joins the percussive conversation. Backyard Band played a concert in front of television station WUSA 9 as part of its five o'clock news on the day following the passing of Chuck Brown.

Middle: Backyard Band's Big G, Buggy and Sauce at Aqua Nightclub.

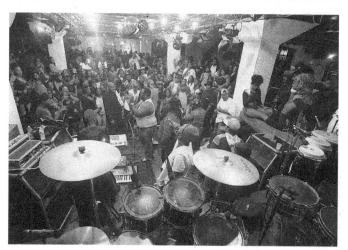

Bottom: Fans pack the Aqua Nightclub for a Backyard Band show. The man dancing center stage was called to the stage as part of his birthday celebration.

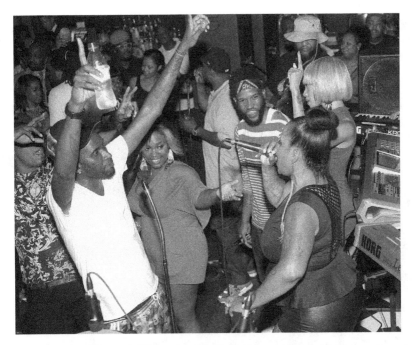

Guest stars Ms. Kim and KK stop by club Capitelle to perform with Backyard Band. *Left to right*: Big G, Lissette TT, fan, KK and Ms. Kim.

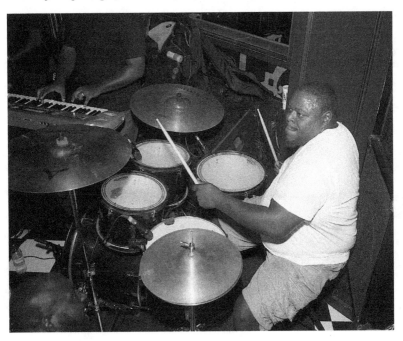

Buggy provides the crank at a Backyard Band show.

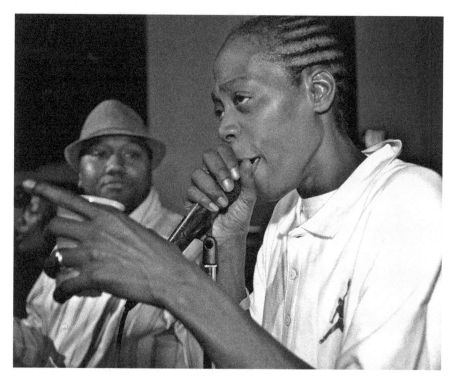

Backyard Band's Weensey sings at Ibiza Nightclub.

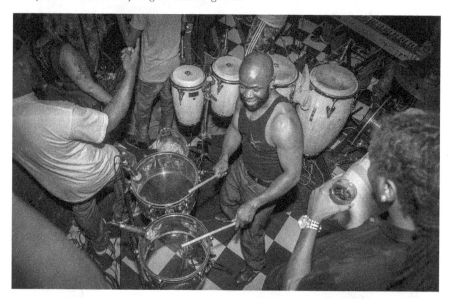

Backyard Band's percussionist Sauce cranking the roto toms at club Capitelle.

TROUBLE FUNK

Trouble Funk is one of the earliest go-go bands and has a rich history of success not only in DC but also on the worldwide stage. Founded by bassist, composer and vocalist "Big Tony" Fisher, the band is known for its early '80s hits "Drop the Bomb" and "Pump Me Up," released on Sugar Hill Records. Signed by Chris Blackwell's Island Records, Trouble Funk toured the world in the '80s.

Locally, Trouble Funk is also known as one of a few go-go bands that stepped outside the DC go-go circuit, playing shows at emerging punk/new wave clubs the 9:30 Club and DC Space and bringing go-go to another, whiter DC audience.

Go-go history was made in the summer of 2020 when Trouble Funk performed at Wolf Trap's famed Filene Center. This was a glass ceiling–shattering event, as Trouble Funk, a go-go band who has toured worldwide, was the first go-go band in Wolf Trap's fifty-year history to perform at the prestigious venue.

Trouble Funk was not playing on the go-go circuit at the time these images were created due to health reasons, but Big Tony did make a few appearances with the Chuck Brown Band. Trouble Funk played a few shows at Strathmore Hall and DC's Emancipation Day celebrations, as well as the annual Barbeque Battle.

Big Tony greets one fan while a second fan places her arm around him for a selfie as the show at Strathmore Hall comes to an end. Concert promoter Daryl Brooks stands behind Big Tony.

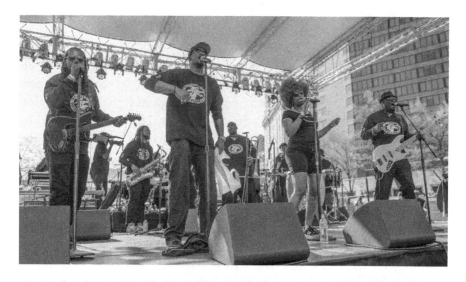

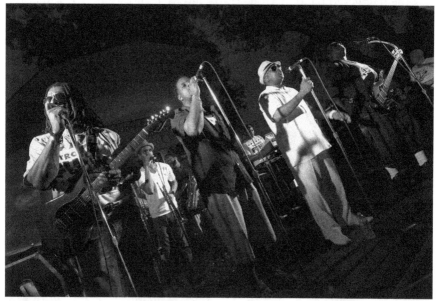

Top: Trouble Funk, with guest Michelle Blackwell, performs at DC's Emancipation Day celebration.

Bottom: Trouble Funk performs on the lawn at Strathmore Hall.

BLACK ALLEY

At first glance, Black Alley doesn't look like a typical go-go band—and they aren't. For one thing, Black Alley maintains a much smaller number of artists in their band, with only seven members and just one vocalist, Kacey Williams. Black Alley has defined their music as soul garage and hood rock. While their set list consists of original songs and R&B covers, there is a lot of rock-and-roll in their music. The guitar often takes a back seat to the percussion in most go-go bands, but Black Alley brings the guitar front and center into their music both onstage and in the studio. Anthony "Red Shredder" Nelson brings his heavy/death metal sound and presence to the stage both musically and visually. Bass player Josh "Josh on Bass" Hartzog not only hammers out the bass lines but also provides an incredible out-front performance as he feels his music and conveys it with stage and dance moves. But with all this soul, R&B and rock out front, the band gracefully moves the audience in DC sound as the show builds intensely into the night with the familiar go-go rhythms from Walter "Bo Beady" Clark on congas and blocks—which he plays simultaneously and sometimes standing backward—and Danny "Animal" Henderson cranking the drums.

In May 2012, Black Alley released their only studio album to date, *Soul Swagger Rock Singer*, but the band continuously releases professionally produced videos with new and often original music. Their videos often focus on urban social issues facing communities of color. Most noted is their video for "Kemosabe," which they released as the #dontmutedc movement was gaining momentum.

With a nimble seven-member band, Black Alley is built to travel, and while they have never gone out of DC on a city-to-city tour, Black Alley often travels outside the city. In 2015, they, along with Rare Essence, represented DC at the South by Southwest music festival in Austin, Texas. Over Labor Day weekend in 2017, they traveled to Paisley Park, Prince's home in Minneapolis, Minnesota, where they had received an invitation to compete in the national Musicology: Battle of Bands against a dozen bands from all over the country. With Prince's band members as the judges, Black Alley took first prize in the contest.

At home in DC, Black Alley held down regular spots outside the go-go circuit, with Thursday nights at Bar Seven and Friday nights at the Breakfast Spot located inside the famed (now-shuttered) jazz club Bohemian Caverns at the time these pictures were created, as well as numerous shows throughout

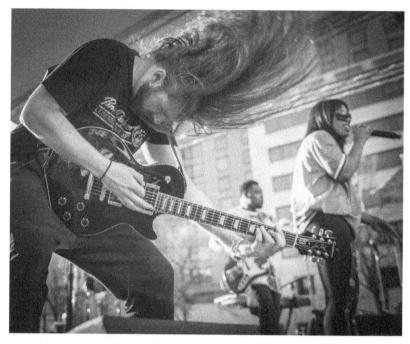

Anthony "Red Shredder" Nelson provides the "rock" for Black Alley's funk/rock/go-go genre. *Left to right*: Red Shredder, Kacey Williams and Josh on Bass.

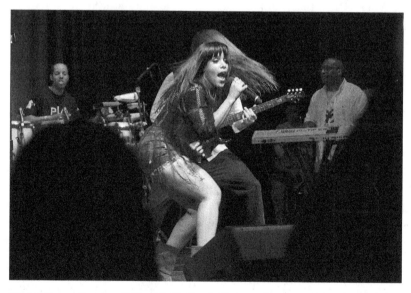

Black Alley performing. *Left to right*: Bo Beady, Kacey Williams, "Red Shredder" and Thomas Mack.

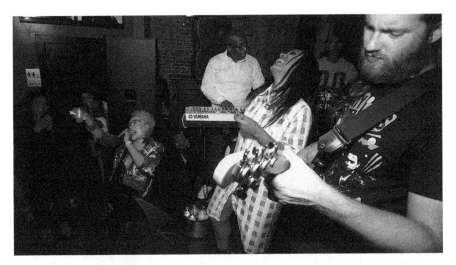

DC rapper Pinky KillaCorn joins Black Alley at Bar 7. Left to right: Pinky KillaCorn, Thomas Mac, Kacey Williams, BeeJay and Red Shredder.

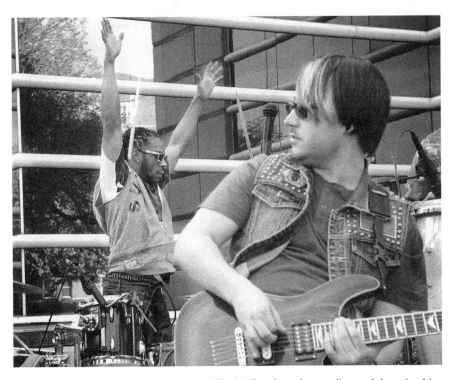

Black Alley's drummer Animal closes most Black Alley shows by standing and dropping his sticks after the last beat.

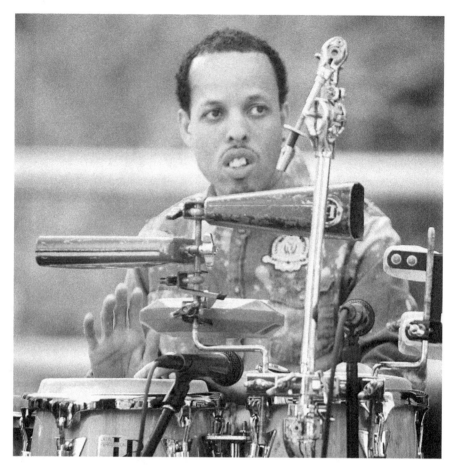

Black Alley's percussionist Bo Beady.

DC. DC mayor Muriel Bowser has described them as her "favorite band," and she can often be seen at their shows.

At the time these images were created, Black Alley's band members were Kacey Williams, vocalist; Josh "Josh on Bass" Cameron, bass; Anthony "Red Shredder" Nelson, guitar; Danny "Animal" Henderson, drums; Walter "Bo Beady" Clark, congas and percussion; and Hope Udobi and Tyson Mack, keys.

VYBE BAND

The smooth vocals of Derrick Holmes and the funky rhythms of Jacques Johnson Jr. give Vybe Band its distinctive go-go style. At the time these images were created, Natasha "MzLaydee" Kelly and Kimise Lee occupied the second and third mics, and Robert "Foxy Rob" Green kept the crank on congas.

This Vybe Band held down shows at regular spots La Fontaine Bleue, My Place Sports Bar, Takoma Station and Layla Lounge. Depending on the economics of the gig, Vybe Band would often perform with a complete horn section.

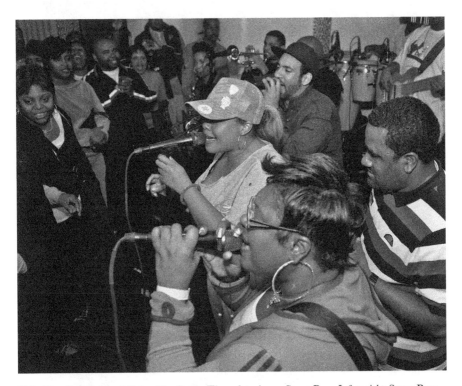

Vybe Band's frontline is joined by Suttle Thoughts singer Steve Roy. *Left to right*: Steve Roy, MzLaydee, Derek Holmes and Kimise Lee.

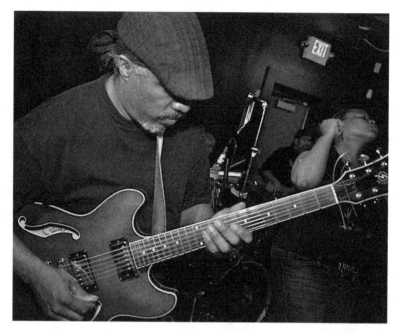

MzLaydee feels the groove created by Jacques Johnson Jr.'s own distinctive rhythm for Vybe Band.

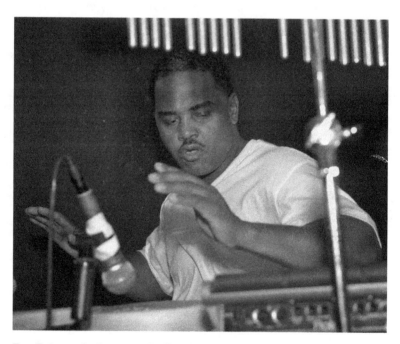

Foxy Rob smacks the congas for Vybe Band.

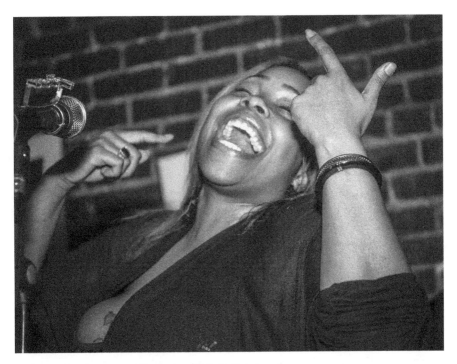

MzLaydee holds a note while singing for Vybe Band.

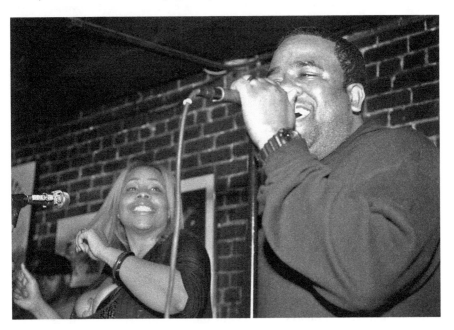

MzLaydee and Derek Holmes of Vybe Band.

JUNKYARD BAND

One of the earliest go-go bands, the members of Junkyard Band not only started out as children from the Barry Farms housing projects in Southeast DC playing instruments fashioned out of junk, but they stayed true to their name by continuing to play the makeshift instruments of buckets, pots and pans and hub caps in their early years as they gained notoriety throughout the city. It wasn't until they signed with Russell Simmons's Def Jam Recording that they began playing regular instruments.

It was their 1986 hit "Sardines and Pork and Beans" that took Junkyard Band (often referred to as JYB) on a nationwide tour opening for Salt-N-Pepa, Tupac Shakur and the Roots. Junkyard Band popularized the go-go dance "The Hee Haw" and has made it a popular part of their show.

Over the years, Junkyard Band has maintained an active presence on DC's go-go circuit. Like many other go-go bands, they have had frequent personnel changes, but bandleader Steven "Buggs" Herrion has held the band together all these years, keeping their authentic sound intact.

DA MIXX BAND

Former members of the Northeast Groovers came together under the leadership of manager Dawayne Nutt to form Da Mixx Band, which quickly developed a strong, loyal fan following and filled the go-go spots of DC.

The band had one of the hardest-cranking backlines with Larry "Stomp" Atwater on drums, Samuel "Smoke" Dews on congas and Curtis "Kirky" Rice on blocks and cowbell, with a frontline consisting of rapper David "32" Ellis, Damila Adams, Duane "Showtyme" Ganey and Tyreke "Freaky Tye" Farmer. The band always performed with a horn section consisting of Anthony Shields, Isaac Wiley and Kevin Coward.

The band's studio single "Da Cook Out," featuring Raheem Devaughn and DC rapper Calvin "Killa Cal" Henry, receives regular airplay on local radio stations, and their live soundboard releases such as "Where the Hell Is Kendra?" are popular among go-go fans.

Da Mixx Band is known for its fan favorite, Power Dance, in which the dancer sticks out their chest and flexes both arms at head level while moving their wrists side to side while the band performs their song "Power," in which the question is asked, "How can a band have so much power?"

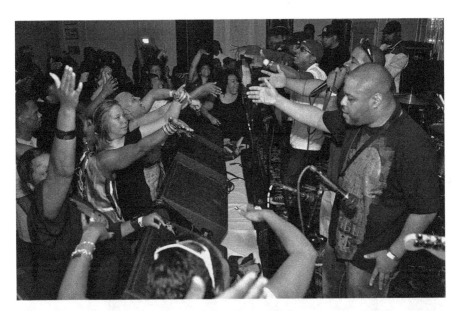

Da Mixx Band and fans. *Left to right*: 32, Showtyme and Anthony Shields.

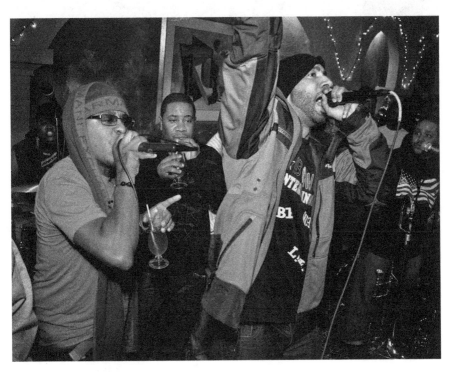

Suttle Thoughts singer Steve Roy appears with Da Mixx Band. *Left to right*: 32, Showtyme, Steve Roy and Anthony Shields.

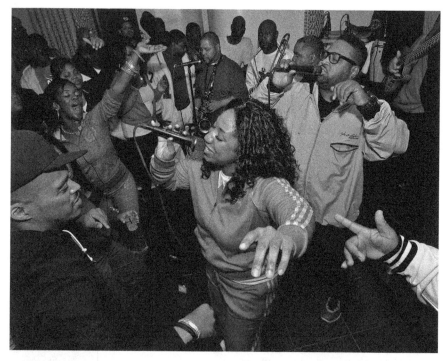

Da Mixx Band with fans, Damilla Adams on mic. *Left to right*: fan Kendra, Anthony Shields, Isaac Wiley, Kevin Coward, Freaky Tye also on the mic.

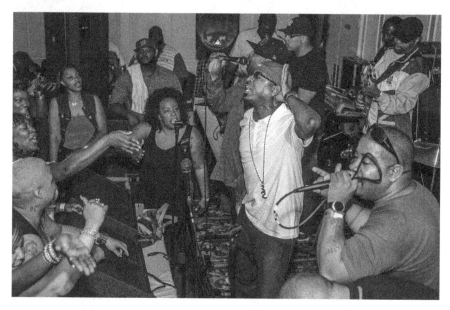

Da Mixx Band. *Left to right*: Freaky Tye, 32 and Showtyme. DC rapper Mo Chips can be seen side stage with a towel over his shoulder.

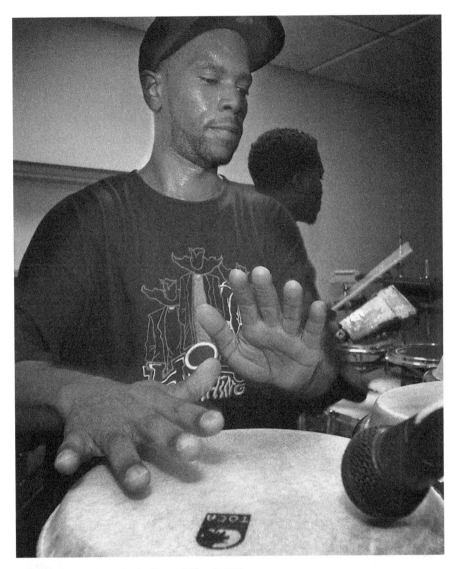

Da Mixx Band percussionist Samuel "Smoke" Dews.

Loyal fans would often join the band onstage performing the Power Dance atop monitors and large speakers. Like all of the dance steps created by go-go bands, the Power Dance became a major highlight of Da Mixx Band shows.

La Fontaine Bleue, Marigolds, Fast Eddies, the Eclipse and Celebrity Banquet Hall were the local go-go spots that Da Mixx Band filled.

LOVE DISTRICT

Love District, a mostly female band, emerged on the go-go scene for a hot minute in the fall of 2011 with a strong frontline consisting of Devin Messina, Kim Scott, Sharli McQueen and Chevy Chevelle. All of these ladies had a strong history in go-go, as well as outside go-go. Kim or Kimberly Scott started performing at a young age, winning amateur night at the Apollo Theater five times when she was five years old. She was signed to a record deal at the age of eleven, and the first single from her first self-titled album, "Tuck Me In," rose to #21 on *Billboard's* Hot R&B/Hip-Hop singles and tracks chart. Both she and Sharli McQueen were part of the early frontline of Bella Dona.

Love District drew lot of attention among the go-go community when a video of one of their early live performances at the club My Place Sports Bar was released. The band played gigs at My Place Sports Bar and Stonefish Grill and even shared the bill with their rival Bela Dona at La Fontaine Bleue.

While gaining a lot of attention in 2011, by mid-2012, for reasons unexplained, this band was nowhere to be found on the go-go scene.

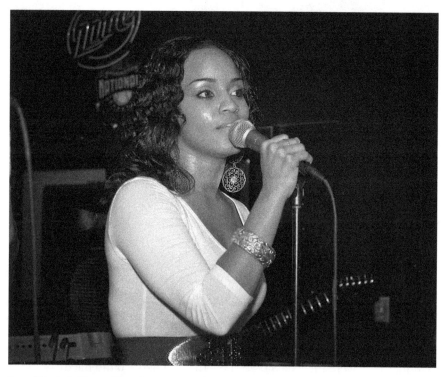

Love District's Chevy Chevelle.

Top: Love District's frontline, Devin Messina, Kimberly Scott and Sharli McQueen.

Bottom: Love District's Kimberly Scott.

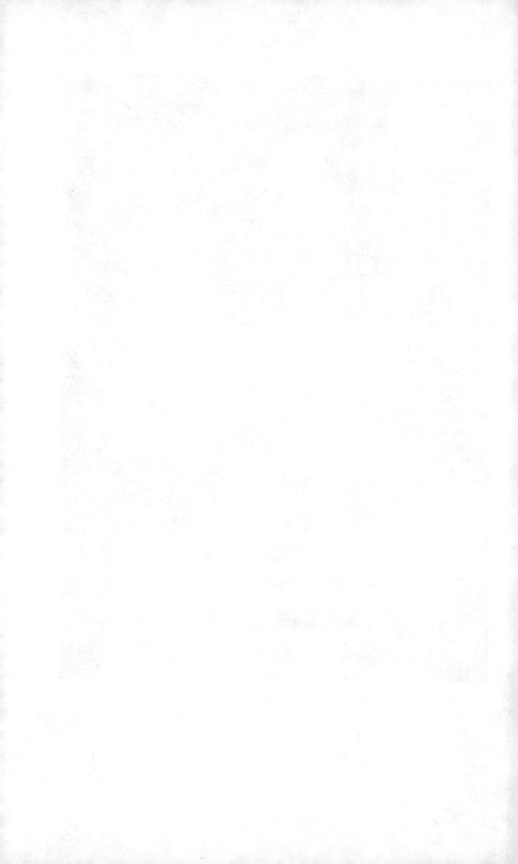

THE DAY CHUCK DIED

It was a warm, sunny spring day on May 16, 2012, as I attached my fishing boat to my truck and started my hourlong drive to the Potomac River. The full bloom of DC's forsythia told me the bass had just moved into the spawn. I knew a few spots where the big bass tended to be on a spring day such as this.

Rumors about Chuck's illness, his absence in DC and canceled shows had been flying through both social media and mainstream media. At an event in Prince Georges County, the Chuck Brown Band had played an outdoor gig without Chuck, having Frank "Scooby" Marshall front the band in Chuck's absence, a week before. At this event, one of the band members had mentioned Chuck's poor health within earshot of a reporter. The following day, the *Washington Post* ran an article wondering why Chuck was missing for this performance and other prior performances that had been canceled at the last minute. The day following the *Post*'s story, the evening anchor of NBC4's evening news broadcast, Wendy Rieger, called me to ask if I had any information about the health of Chuck Brown. Calls started coming from other news media outlets too. With all of this going on, I thought it was a good idea for me to escape to the Potomac River for a day of bass fishing, one of my other passions.

As I drove though the Towne of Poolesville, it dawned on me that Chuck's daughter Cookie had not downloaded the pictures from her birthday party at Takoma Station with Familiar Faces that I had shot for her the previous weekend. Something for some reason told me to turn the boat and truck

around. As I pulled into my driveway, my phone blew up. With my phone ringing and pinging, I sat in my truck and tuned in all-news radio station WTOP, where the news became official:

Chuck Brown, the Godfather of Go-Go, dead at seventy-five years of age

I became emotional as I put my boat away and went into the house. I felt I should do something, but I had no idea what it was I should do. Just then, my phone rang, and it was Chuck's daughter Cookie. She told me that DJ Dirty Rico, a popular go-go and radio disc jockey, was telling everyone in go-go to go to the newly renovated Howard Theatre, the historic space where Chuck Brown shined shoes as a kid and played many shows prior to its closing from structural damage years earlier. Chuck Brown was scheduled to perform at the Howard Theatre's grand opening, along with Bill Cosby, the previous month but had canceled his appearance for health reasons.

As I left my Silver Spring home to go to the Howard Theatre, I slid a Chuck Brown CD in my player. Just after I crossed the DC line on Georgia Avenue, I shut off the CD player and lowered my windows. I could hear the beat of the city playing all through the streets and neighborhoods, which provided some comfort to me. The beat coming from the streets where it originated let me reflect on the work I had done the last two years and

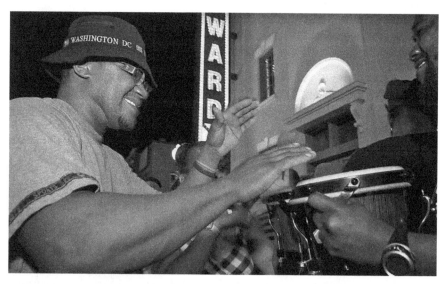

Chuck Brown's conga player Mighty Moe plays a small set of congas while the crowd chants, "Wind me up, Chuck!" outside the Howard Theatre, where people had gathered on the evening of Chuck Brown's passing.

how lucky I was to have the opportunity not afforded to many people who look like me. Not only was I able to capture these photographs, but also as someone who has lived in the DC suburbs most of my life, someone who loves live music, through my work with Chuck and other bands I was able to "feel" the city—to actually know DC not through its houses of governments, museums and monuments but through the culture of the majority of its residents. I drove slowly the rest of the way down Georgia Avenue feeling the city and the streets percussively speaking to me, and I am certain, on this night many others in DC felt this way as well.

Parking was tight around the Howard Theatre, I found parking blocks away, and as I walked up Chuck Brown Way to the Howard, I could hear Chuck's music being played on loudspeakers. There in front of the Howard Theatre, I found thousands of people dancing. I saw people weeping in the street. Moments after I arrived, I found Chuck's biggest fans, Kevin Jones and Penny "Chinchilla" Braxton, standing in the middle of the large crowd that had assembled. We had a group hug and wept together. I then got myself together, filming the crowd, the music, the dancing, the crying.

I found Chuck's conga player Mighty Moe and led him to a group of folks who were trying to play a small set of bongo drums. Moe soon took over, playing those bongos with all his heart as the crowd called out, "Wind me up, Chuck!"

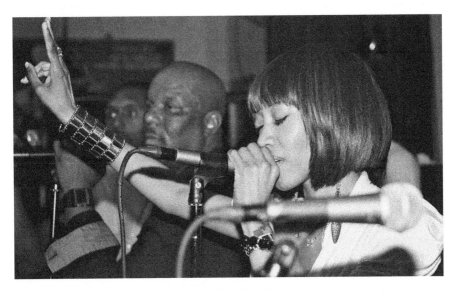

Ms. Kim and Familiar Faces bandmates D. Floyd and Quisey struggle to keep the go-go going while performing at a club on the night of Chuck's passing.

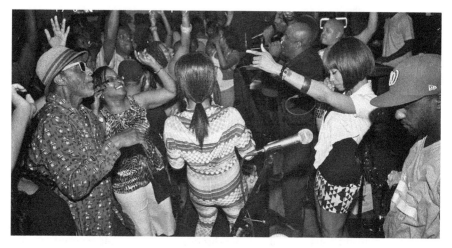

Go-go is the music that never stops. Familiar Faces performs through their emotions while the party keeps going on the night of Chuck Brown's passing at Martinis Nightclub.

As the activities at the Howard started to go on well into the night, I started to wonder what was happening at the go-go shows scheduled for that night. I knew that Familiar Faces was playing at a club in Fort Washington, so I decided to drive down there.

When I arrived at the club, what I saw was poignant. The band members in Familiar Faces, most of whom had been at one time or currently were members of Chuck Brown's band, were distraught as they played through their set while the crowd directly in front of them was having a party. There was a stark contrast and a dividing line between the two emotions. The photos that I took the night of Chuck Brown's passing are haunting to me, and I am certain the artists in these photos find them haunting too.

A CITY MOURNS, A CITY REMEMBERS

In the days that followed the passing of the Godfather of Go-Go, indications of a mourning city were abundant. Radio stations played nonstop go-go, television stations invited go-go bands to perform on local news broadcasts and spontaneous memorials sprang up in places of significance. Makeshift signs saying, "Honk for Chuck" and "Chuck Baby Don't Give a What?" sprang up on corners and in storefront windows. Vendors set up on corners selling Chuck Brown T-shirts and hats. One couldn't make it through a DC intersection without hucksters approaching the car selling cheap knockoff T-shirts; some even had pictures on them of someone in a hat and glasses that wasn't Chuck.

Just around the corner from the Howard Theatre on Chuck Brown Way, a woman was seen posting a note on a street pole demanding that the BET Awards do a tribute to go-go. This became iconic when the BET Awards did a tribute to go-go seven years later.

In the Petworth neighborhood, students of nearby McFarland Middle School painted a large mural of Chuck Brown on the front-facing side of the popular Mango Café. Other murals would follow at places like Ben's Chili Bowl on U Street and Columbia Heights.

The day following Chuck's passing, the Backyard Band played a tribute set in front of WUSA Channel 9's studio on Wisconsin Avenue, which was patched into the evening news program. The following weekend, an impromptu go-go show was added to the annual Smithsonian Folk Life Festival on the mall.

Signs like this appeared in DC in the days following Chuck Brown's passing.

On Thursday evening, two days after Chuck's passing, go-go fans packed La Fontaine Bleue, a large catering house in Lanham, Maryland, where Martin Cooper's Made in the City Entertainment had been attracting a large Thursday night crowd for several years. As the headlining band, Suttle Thoughts, took to the stage, stage manager Lorretta "Clipboard" Sims let the band and those of us gathered side stage know that Chuck's daughter KK, who had been absent from the scene for the last few months while she cared for her father, was on her way to "the Bleue" to do a walk-on performance with Suttle Thoughts.

KK arrived at the Bleue styled in her own funky fashion that she always brings to the stage. As she hit the stage, the large crowd went wild, showing their love for her and her family. To say there was a lot of love in that room on that night is an understatement. As KK rolled through her pointed raps, front-row fans extended their hands to her. Following KK's performance, folks lined up, in go-go tradition, to have photos taken with her.

That weekend, the *Washington Post* printed an extra edition of its Sunday paper all about Chuck Brown and what he created in Washington, DC. In

T-shirt vendors popped up around DC in the days following Chuck Brown's passing.

An unknown fan tapes a flyer on a post on Chuck Brown Way calling for the BET Awards to honor go-go in the days following Chuck's passing. In June 2019, the BET Awards, hosted by actress and DC native Regina Hall, did a go-go tribute almost exactly as this woman had requested.

Above: Just days after Chuck's passing, schoolchildren painted this mural in the Petworth neighborhood of DC.

Opposite: Chuck Brown's daughter KK makes a surprise appearance at La Fontaine Bleue just two days after her father's passing.

my adult years, there have been only three times I could remember the *Post* printing an extra edition: the beginning of the Gulf War, the election of Barak Obama and now the passing of Chuck Brown.

In the days and weeks following the Godfather's passing, people started to wonder and speculate about where a service would take place. Where would they put all the people who loved Chuck and the music and culture he created? Just before Memorial Day, it was announced that there would be two services the following week. The first would be a viewing at the newly renovated Howard Theatre on Tuesday, May 29, 2012, with a full homegoing service on Thursday, May 31, at DC's Walter E. Washington Convention Center.

People began lining up early Tuesday morning at the Howard Theatre, as the weather forecasters had called for a very hot, humid day. The TV press lined itself up across from the theatre, doing interviews with go-go

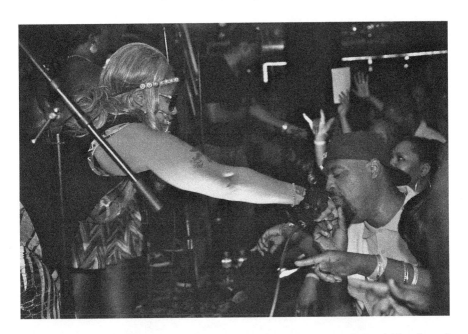

artists, DC politicians and passersby. Chuck Brown's music could be heard from multiple sources. Vendors lined the street. In go-go tradition, a photo backdrop with pictures of Chuck was set up, offering photos posed in front of the backdrop for ten dollars each or two for fifteen dollars. The crowd grew in size, and the line went down the block onto the stretch of Georgia Avenue known as Chuck Brown Way. People sweltered in the heat and humidity, waiting to enter the Howard Theatre to pay their respects, walking slowly past Chuck in his open casket dressed in his signature fedora and sunglasses. Former band members and politicians arrived, and Mayor Vince Gray spent the morning shaking hands with those who had come to pay their respects.

While the viewing was scheduled to go on until 10:00 p.m. so those with nine-to-five jobs could also pay their respects, it was cut short in the late afternoon when a thundering downpour began. While there was no official count, some have said that over twenty thousand people stood in line to pay their respects.

Just like two days prior, the lines formed early outside the Walter E. Washington Convention Center. When the doors opened promptly at 10:00 a.m., thirty thousand people flooded the large room where Chuck's flower-covered closed casket sat in front of the stage set with a podium. The service, hosted by DJ Donnie Simpson, started out somber as Reverend Dr. Tony Lee gave a few words and led the room in prayer, followed by a performance from the Howard University Gospel Choir. But the feel of the

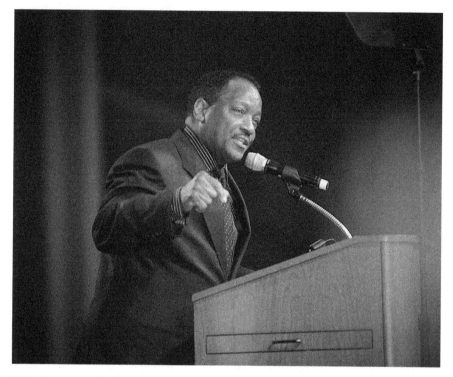

DC radio personality Donnie Simpson hosted a star-studded Homegoing for Chuck at the DC Convention Center.

room quickly moved from sorrow to celebration with short performances from a star-studded list that included Mike Epps, Tye Tribbett, Huggy Lowdown, Sugar Bear, Raheem DeVaughn, Doug E. Fresh, Kindred the Family Soul, Cliff Jones, Big G, Chris Paul, Ledisi, Tom Joyner and finally the Chuck Brown Band.

Interspersed between these artist performances, DC politicians Eleanor Holmes Norton, Mayor Gray, former DC mayor and then councilmember Marion Barry, music promoter and DC native Darryll Brooks and fight promotor and DC native Rock Newman all took to the podium to share their perspectives of Chuck Brown and the impact he had on the city. Mayor Vincent Gray drew applause from the crowd when he announced that the city had declared August 22 as Chuck Brown Day and the city would build a park in honor of the Godfather of Go-Go with a nine-hundred-seat music venue named the Chuck Brown Park.

The final speakers of the day were the grown children of Chuck Brown, led by KK, the eldest. She wanted everyone to remember, "We are Chuck's

babies." Remarks followed from her brothers and her son. When they finished up, the Chuck Brown Band took the stage with Frank "Scooby" Marshall stepping into Chuck's shoes and leading the band into a full set of Chuck Brown favorites, which moved the room to sheer joy in the celebration of Chuck's life. As the band began to play, an honor guard of pallbearers slowly carried Chuck's casket from the room to a custom hearse befitting of the funk icon. Chuck was buried later that day in a private graveside service attended only by family members.

Chuck Brown Park opened on Chuck Brown Day, August 22, 2014. The scaled-down park (the nine-hundred-seat music venue was removed from the plans early in the planning when nearby neighbors raised concerns) featured an interactive sculpture of Chuck and a photo wall of nine-by-fourteen-foot images baked onto tiles and assembled as mosaics arranged in a timeline with captions describing his life and musical career. A new playground was built that featured congas and other percussive instruments for the kids. One of this author's photos is included in this exhibit.

Members of the go-go community anxiously waited in the light rain as Mayor Vince Gray spoke from the podium to and about DC government staff who had a role in the building of the park, while the Chuck Brown Band stood behind him on the temporary "showmobile" stage waiting to christen the park with some go-go music.

As Mayor Gray was finishing up his lengthy speech by calling for "hands in the air for Chuck," DC's former mayor and councilmember Marion

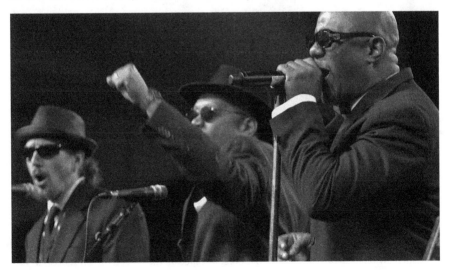

D. Floyd kicks off the Chuck Brown Band at the end of Chuck Brown's homegoing.

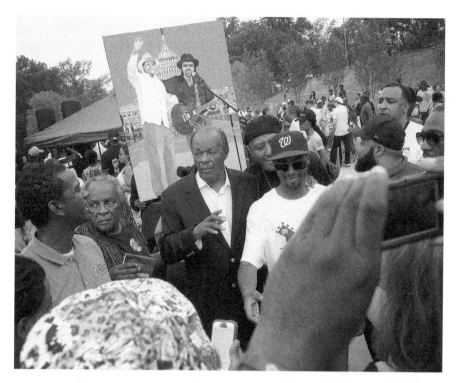

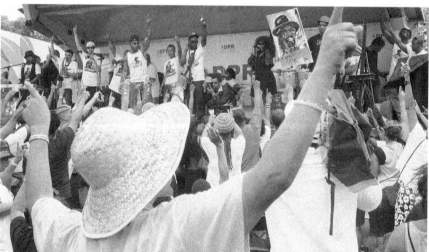

Top: DC activist Elwood "Yango" Sawyer helps DC's Mayor for Life, Marion Barry, to the stage at the grand opening of Chuck Brown Park.

Bottom: Following Mayor Barry's brief but poignant speech, the Chuck Brown Band plays at the grand opening of the Chuck Brown Park.

Kids play with the conga drums that are a permanent part of the Chuck Brown Park.

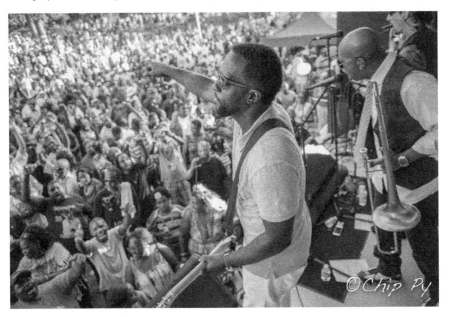

Frank "Scooby" Marshall leads the Chuck Brown Band for the Chuck Brown Day celebrations at Chuck Brown Park.

Barry, who was often referred to by DC folks as "Mayor for Life," slowly made his way up the rear stage steps. On nimble legs, the aging politician grasped the hand of Chuck's longtime stagehand Christopher Lee for support. Speaking through one of the band's microphones, he said, "Just like Chuck Baby, I don't give a what. This is Chuck Brown's day. Chuck Brown is a legend. He is the Godfather of Go-Go. Equally, there are other groups around—EU, Rare Essence, Sugar Bear. I know Chuck very well. He is legend. He is a genius. What Chuck Brown did is come right out of jail, made something of himself. Which oughta be an inspiration for any of you who have gone through anything, that you can get knocked down, but you can also get back up. If anyone knows about getting back up, it's Marion Barry!" The crowd cheered, the band began to play and the crowd danced in celebration.

The park has become the center point for Chuck Brown Day celebrations in the years since. With a multi-band lineup headlined by the Chuck Brown Band, several thousand people attend each year. At this event, the Chuck Brown Foundation, which Chuck's sons Wiley and Nekos Brown founded, hands out backpacks filled with school supplies to families in need.

DON'T MUTE DC AND THE FUTURE OF GO-GO

The word *catalyst* is defined "as a person or thing that precipitates change." A major catalyst came to go-go in the shape of a movement that quickly became known as #dontmutedc.

Donald Campbell had been playing recorded go-go music on two small speakers in front of his cellular phone store on Florida and Georgia Avenue—the three-block section of Georgia Avenue named Chuck Brown Way—in the northeast quadrant of DC since 2005. His corner store, known as Central Communications, did a steady business with residents of this area, offering pre-paid cellular services, phone accessories and recordings of live go-go performances. People passing by the store would often pause and dance a two-step there. Strangers danced with each other. For many years, it was not unusual for passersby to see a handful of people dancing and enjoying the music on that corner.

When Campbell opened up shop in 2005 in the predominantly African American neighborhood of Shaw, not far from Howard University, the area consisted of boarded-up storefronts and rundown row homes. The neighborhood remained this way for most of the years that Campbell did business there. When the city restored and reopened the once-grand Howard Theatre—a broken-down shell that once hosted greats like Duke Ellington, Ella Fitzgerald, James Brown and the Supremes—in April 2012, the *Washington Post* ran an article questioning if the newly renovated theatre would be enough to spark development in the neighborhood of liquor stores, pawnshops, a funeral home and boarded-up windows.

Donald Campbell at his Central Communications store.

With gentrification marching strongly through Washington, DC, it was not long before it became obvious that the authors of the *Washington Post* article would soon eat their words. Restaurants, brewpubs and trendy bars opened quickly, and within a few years, whole blocks of row homes and storefronts were cleared and construction of expensive apartments and condominiums began.

With this came new neighbors.

As the new neighbors moved into the luxury apartments and condominiums, the racial makeup of the neighborhood changed. Neighbors in the high-rises started to grumble about the music in front of Central Communications. The Department of DC Regulatory Affairs began getting complaints from the neighbors. Even though the inspectors showed up with sound-measuring equipment several times and measured the sound at reasonable levels for an urban neighborhood (the noise levels from traffic pulling off and through the intersection were louder than the music from the small speakers), the residents were still unhappy. One new resident told well-known activist Ron Moten that the music was "disrespectful to the neighborhood."

In the spring of 2019, the Shay, a newly opened apartment building, boasted on its website that it was located in the heart of nightlife and culture.

A two-bedroom apartment there rented for $4,375 per month. It was a resident at the Shay who came up with an idea. He proposed that he and fellow residents get in touch with T-Mobile, Central Communications' mobile services provider, and complain about the music being played in front of the store. They threatened to boycott the brand and possibly bring legal action.

In late March, Donald Campbell began to hear from his representatives at T-Mobile about how he should "tone it down," and eventually, he was told to turn the go-go off—the music that never stops.

Like the click of a hand grenade, it was just a matter of hours before people took notice and a firestorm of events began that would have a profound shape on the future of go-go and the city of Washington, DC.

One person who took immediate notice was Julien Broomfield. A senior at Howard University, Broomfield instantly noticed the absence of the music and joy that she had grown accustomed to seeing and "feeling" on that corner as she drove by. On Saturday, April 6, she popped into the store, asking why there was a sudden absence of go-go music on the corner in front of the store. She was told that T-Mobile had received complaints from the neighbors and threatened to shut the store down if they didn't turn off the music. Someone in the store explained to her that they had no choice. Being familiar with how gentrification had changed her hometown of Newark, New Jersey, Broomfield found herself livid and posted her feelings in a 2:44 a.m. Tweet. By the time she woke up the next morning, her tweet had gained momentum, and later in that day, Broomfield coined the hashtag #DontMuteDC. Within hours, that hashtag was trending.

Taking notice of these events from across the city in Southeast DC was activist Ron Moten, who was known for his work with at-risk youth, gang violence and returning citizens, and author and professor Dr. Natalie Hopkinson, whose book *Go-Go Live: The Musical Life and Death*

of Chocolate City discusses how gentrification has not only pushed go-go music out of the city but has marginalized the people and culture of the city too. The two had been working together for several years.

By Monday morning, April 8, Moten and Hopkinson were speaking with Campbell. The discussion had turned to the fact that this action by T-Mobile was bigger than Central Communications, bigger than themselves, even bigger than go-go. This action represented the entire social crisis that African Americans were facing not only in Washington, DC, but in every city from the systematic destruction of African American neighborhoods and the neighborhood culture. They knew that this was the time to take a stand. The pair set up an online petition directed toward T-Mobile titled "Don't Mute DC's Go-Go Music and Culture."

By day's end on Monday, April 8, the online petition had over eighty thousand signatures.

That same Monday afternoon, artist, activist and founder of the socially driven We ACT Radio Kymone Freeman organized a protest across the street from Central Communications that included a live go-go band. As the news spread rapidly, people started coming to the corner. The crowd grew. By the evening rush hour, the crowd had spilled out into the busy intersection and shut down traffic. The message was clear from that corner and from throughout the city that go-go was here and was not going anywhere.

The local politicians also quickly took notice. City Councilmember Brianne Nadeau, who represented the Shaw neighborhood, announced through Twitter early Monday evening that she had reached out to T-Mobile to inform them about the cultural significance of that corner. On Tuesday afternoon, Mayor Muriel Bowser, a DC native, tweeted the #dontmutedc hashtag, saying, "I'm with you" and sharing the petition link.

On Tuesday evening, Ron Moten and go-go promoter and activist Justin "Yaddiya" Johnson, who had founded the social justice movement Long Live Go-Go a few years prior, staged a protest in front of the DC Government Building at 14th and U Streets, NW, known as the Reeves Center. This protest, the first of several rallies known as Mochella (a combination of the two words "Moe," common DC slang for homeboy/girl, and "Coachella," the California music festival), featured go-go bands Mental Attraction Band (MAB), Alla Bout Money (ABM) and the hugely popular Take Over Band (TOB).

In its heyday, U Street was known along the East Coast as the "Black Broadway." Just blocks from Howard University, its streets and corridors were lined with black-owned theaters, jazz clubs, bars, bookstores and

coffeehouses. The famous rock club the 9:30 Club that resides just off U Street was originally Duke Ellington's own jazz club known as Ellington's. The Howard and Lincoln Theatres and several others hosted a who's who of Black entertainment and intellect. Poet Langston Hughes lived off U Street for a couple of years, and Duke Ellington was born and raised not far from U Street.

After the 1968 riots following the assassination of Reverend Dr. Martin Luther King Jr., while Black-owned U Street businesses like Ben's Chili Bowl and Lee's Flowers saved their businesses from destruction by spray-painting "Soul Brother Owned" on their boarded-up windows, U Street and the Shaw neighborhoods surrounding them were never rebuilt. Little business or housing investment was made in this area for nearly thirty years. However, on many nights during those thirty years, people could hear the familiar beat of go-go music lofting out in the streets from clubs like Republic Gardens, Masonic Temple and Club U, all located near the corner of 14th and U. As the city began to gentrify in the mid-2000s, investment came back to U Street in the form of luxury high-rise condominiums, apartments, restaurants and such.

The corner of 14th and U Streets set the stage appropriately for that evening's protests and others to come shortly.

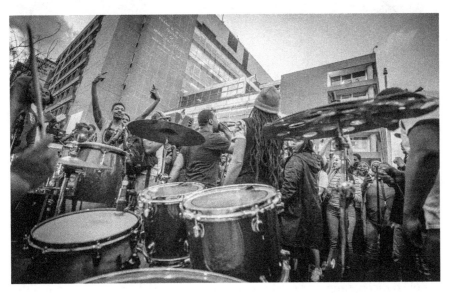

Alla Bout Money (ABM) band demonstrate in front of the Reeves Center at the first #dontmutedc demonstrations.

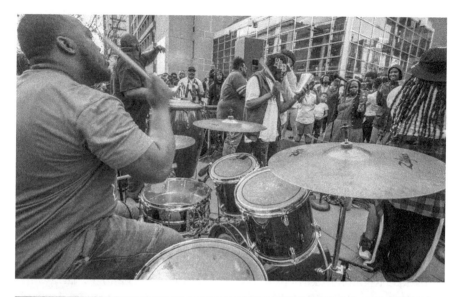

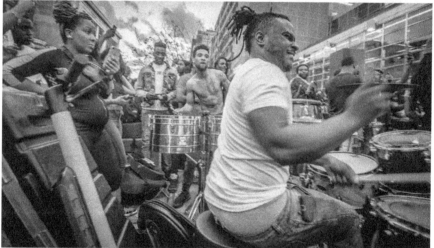

Top: Mental Attraction Band (MAB) demonstrate in front of the Reeves Center at the first #dontmutedc demonstrations.

Bottom: Percussionists from the Take Over Band (TOB) demonstrate in front of the Reeves Center at the first #dontmutedc demonstrations.

The people showed out! The crowds grew well into the thousands as people danced, sang and celebrated their culture well into the night and the crowds spilled out into the streets. Activists spoke between sets. DMV native and internationally known rapper Wale arrived and performed with one of

When she found out her culture was being threatened, this DC woman drove down from Baltimore, where she was attending Morgan State University, to join the demonstration at 14ᵗʰ and U Streets. Behind her, a man from one of the condos demands the police officer shut down the demonstration. How ironic.

the bands. Famed go-go portrait photographer Mr. Gee was there with Rare Essence as a backdrop. DC police had a visible presence and provided street barriers, crossing guards and other safety services to keep everyone safe, as they do at the many protests that take place in the nation's capital. As the number of demonstrators grew, the barriers were moved farther and farther out into the streets. A resident from one of the expensive apartments was spotted trying to tell a police officer that this had to stop immediately.

The protest garnered a lot of media attention from the local TV stations and news outlets, as well as being streamed live on many social media outlets.

At noon the following day, T-Mobile chief executive John Legere tweeted, "I have looked into this myself, and the music shall not stop in DC." Moments later at a press conference in front of Central Communications, the music began to play again.

But this was not over.

Activist Ron Moten had said just days before, "This is bigger than us." Silencing the go-go music on a corner in Shaw was just the picking of a scab from a deep wound. The activists, musicians, members of the go-go community and neighborhood leaders knew that this was the moment to bring attention to the city about issues that have affected their communities for too long.

The pop-up musical protests continued regularly for the next month, drawing attention to the fact that the rapid gentrification of DC was stripping away any sense of culture the city had and marginalizing the people who were part of it. The voices of the people who built, worked and lived in the city for generations and their needs had simply been ignored as the city prospered. The attention of the protests shifted in their purpose from the music and culture being silenced to issues of affordable housing, healthcare, jobs, displacement and returning citizens. People came out in droves with the message, "We are here too. We have needs too."

For the remaining part of 2019 and early 2020, go-go bands played on roving trucks throughout the city, drawing attention to their presence and needs. Go-go protests occurred daily in the city in the days following the killing of George Floyd, and Mayor Muriel Bowser dedicated several blocks in front of the White House "Black Lives Matter Plaza." Political pressure began being applied to those in power.

In the fall of 2019, Ward 5 councilmember Kenyan McDuffie introduced Bill 23-317, the Go-Go Music of the District of Columbia Designation Act of 2019, to make go-go the official music of Washington, DC. It called for implementation of a program to support and archive go-go music and its history in DC. Funds were also set aside for programs through the DC Offices of Cable and Television and Events DC to promote go-go.

The council passed the bill unanimously, and on February 19, 2020, Mayor Muriel Bowser signed the bill into law. Go-go music is the official music of Washington, DC!

The following year, the council and mayor awarded some funds for the promotion of go-go music and grants for go-go musicians and the preservation of go-go history and culture.

The future of go-go is now facing a turning point in its long story. With recognition from the DC government, there is opportunity to not only want to preserve go-go but also move it to the forefront of DC's number-one industry, tourism, like the cities of New Orleans, Austin and Nashville do. How will go-go respond? As the city's population changes, will the new residents begin to embrace go-go beyond just buying a T-shirt? How will

the go-go business model adapt to these new opportunities? As Greg Boyer said in the foreword of this book, "Go-go is the DNA of DC. If you know anything about biology, DNA does not change." Go-go has a tremendous resilience to it. It has always adapted to the constant changes and many challenges it has faced for the last fifty years. Go-go will always be part of the city of Washington, DC, and many more chapters of its history have yet to be written.

ABOUT THE AUTHOR

Photo by Sheryl Adams.

Chip Py began taking photographs at a young age while he tagged along with his father, a newspaper reporter. He studied history at East Carolina University and moved to Washington, DC, in 1988. An avid live music fan, Py has been shooting DC bands of all genres for over twenty years. One of his photographs is on permanent display as part of Chuck Brown Memorial Park. His go-go portfolio was acquired by the People's Archive of the DC Public Library in 2020, and the *Washington City Paper* gave him the Editor's Choice Award for his work in 2021.